Remembering
Marilyn

LIFE

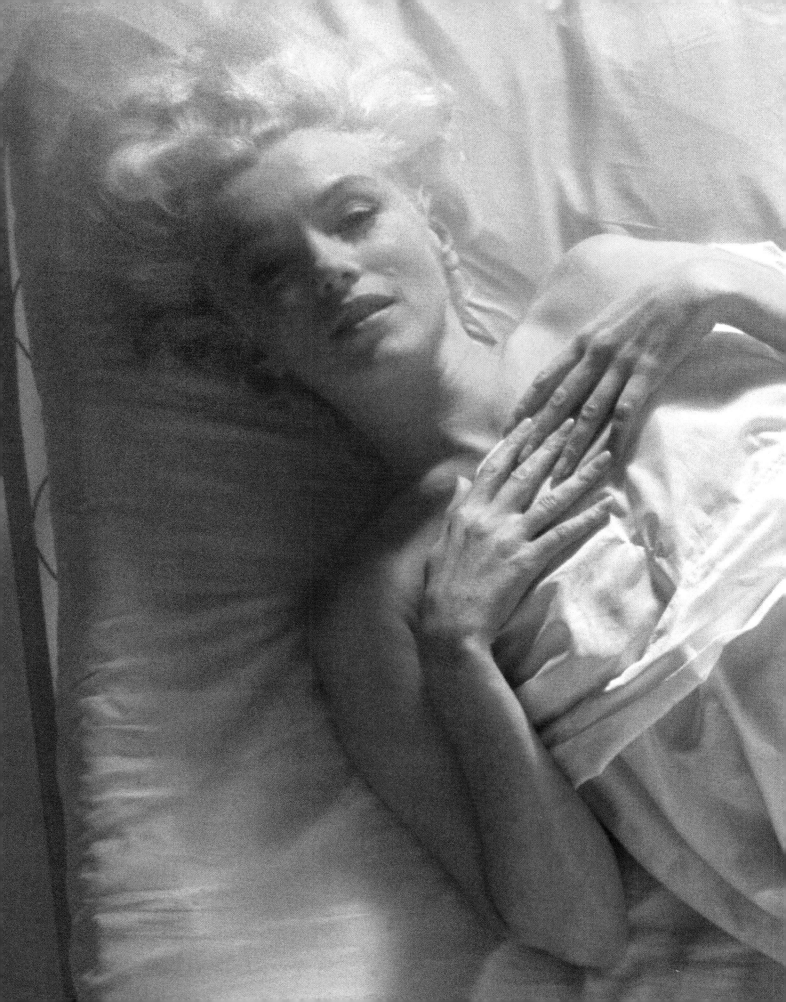

Remembering
Marilyn

From the Editors of **LIFE**

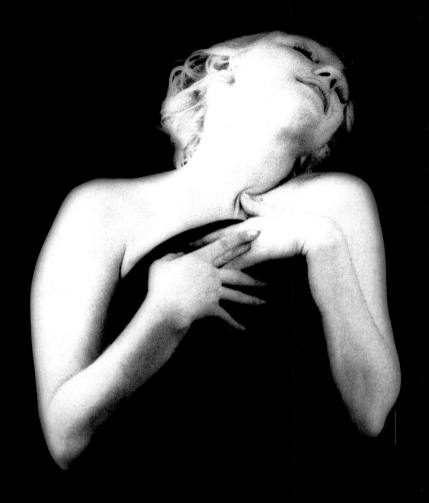

LIFE Books

Editor *Robert Sullivan*
Director of Photography *Barbara Baker Burrows*
Art Direction *Richard Baker, Anke Stohlmann*
Deputy Picture Editor *Christina Lieberman*
Writer-Reporter *Hildegard Anderson*
Senior Writer *Danny Freedman*
Copy Editors *Parlan McGaw* (Chief), *Danielle Dowling*
Consulting Picture Editors *Sarah Burrows, Mimi Murphy*
(Rome), *Tala Skari* (Paris)
Special thanks to *Ted D. Ayres*

President *Andrew Blau*
Business Manager *Roger Adler*
Business Development Manager *Jeff Burak*

Time Inc. Home Entertainment

Publisher *Richard Fraiman*
General Manager *Steven Sandonato*
Executive Director, Marketing Services *Carol Pittard*
Director, Retail & Special Sales *Tom Mifsud*
Director, New Product Development *Peter Harper*
Assistant Director, Bookazine Marketing *Laura Adam*
Assistant Publishing Director, Brand Marketing *Joy Butts*
Associate Counsel *Helen Wan*
Book Production Manager *Suzanne Janso*
Design & Prepress Manager *Anne-Michelle Gallero*
Brand Manager *Shelley Rescober*

Special thanks to *Glenn Buonocore, Jim Childs,*
Susan Chodakiewicz, Jacqueline Fitzgerald, Rasanah Goss,
Lauren Hall, Jennifer Jacobs, Brynn Joyce, Robert Marasco,
Amy Migliaccio, Brooke Reger, Ilene Schreider,
Adriana Tierno, Alex Voznesenskiy, Sydney Webber,
Jonathan White

Editorial Operations *Richard K. Prue* (Director),
Brian Fellows (Manager), *Keith Aurelio, Charlotte Coco,*
John Goodman, Kevin Hart, Norma Jones, Mert Kerimoglu,
Rosalie Khan, Patricia Koh, Marco Lau, Brian Mai,
Po Fung Ng, Lorenzo Pace, Rudi Papiri, Robert Pizaro,
Barry Pribula, Clara Renauro, Donald Schaedtler,
Hia Tan, Vaune Trachtman, David Weiner

Published by LIFE Books
Time Inc.
1271 Avenue of the Americas
New York, NY 10020

Vol. 9, No. 6 • July 24, 2009

"LIFE" is a trademark of Time Inc.

We welcome your comments and suggestions
about LIFE Books. Please write to us at:
LIFE Books
Attention: Book Editors
PO Box 11016
Des Moines, IA 50336-1016

If you would like to order any of our hardcover
Collector's Edition books, please call us at 1-800-327-6388
(Monday through Friday, 7:00 a.m.–8:00 p.m.,
or Saturday, 7:00 a.m.–6:00 p.m., Central Time).

Remembering Marilyn

Cover: *Marilyn at home in Hollywood in 1953, photograph by Alfred Eisenstaedt.*

Page 1: *In 1949, photograph by Philippe Halsman.*

Pages 2–3: *In 1961, photograph by Douglas Kirkland.*

These pages: *In 1956, photograph by Milton H. Greene/Legends.*

Back cover: *In 1959, photograph by Philippe Halsman.*

Candle
in the Wind

Born Norma Jeane Mortensen and baptized Norma Jeane Baker, the future film star is already lovely as a five-year-old girl in 1931.

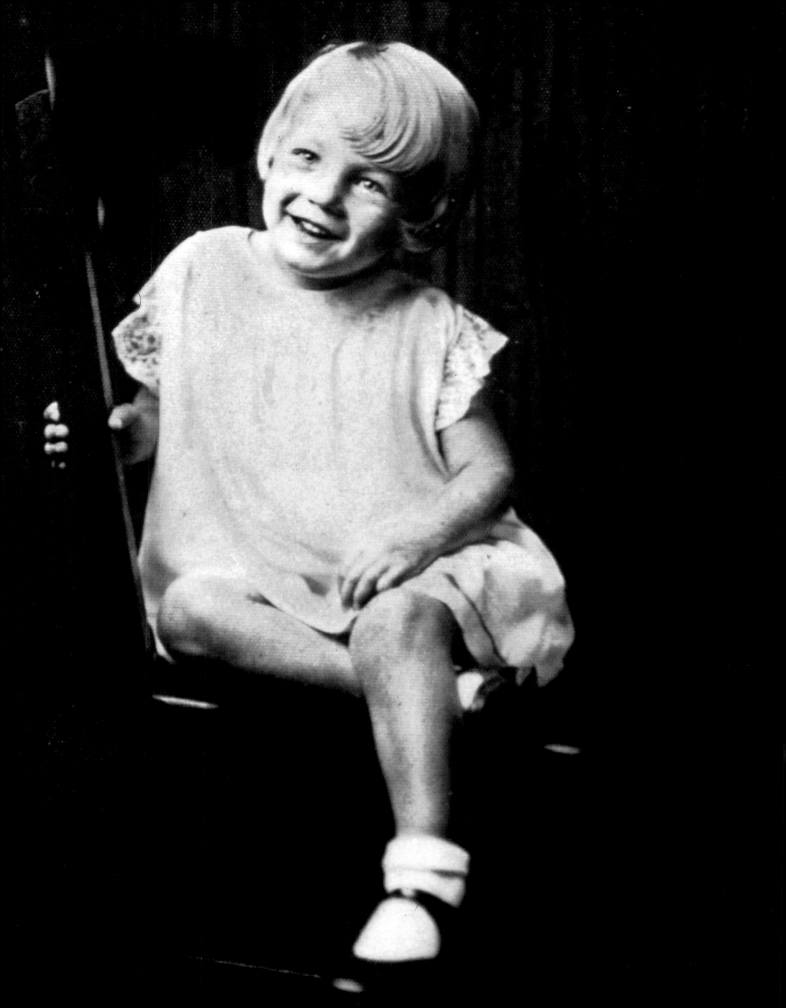

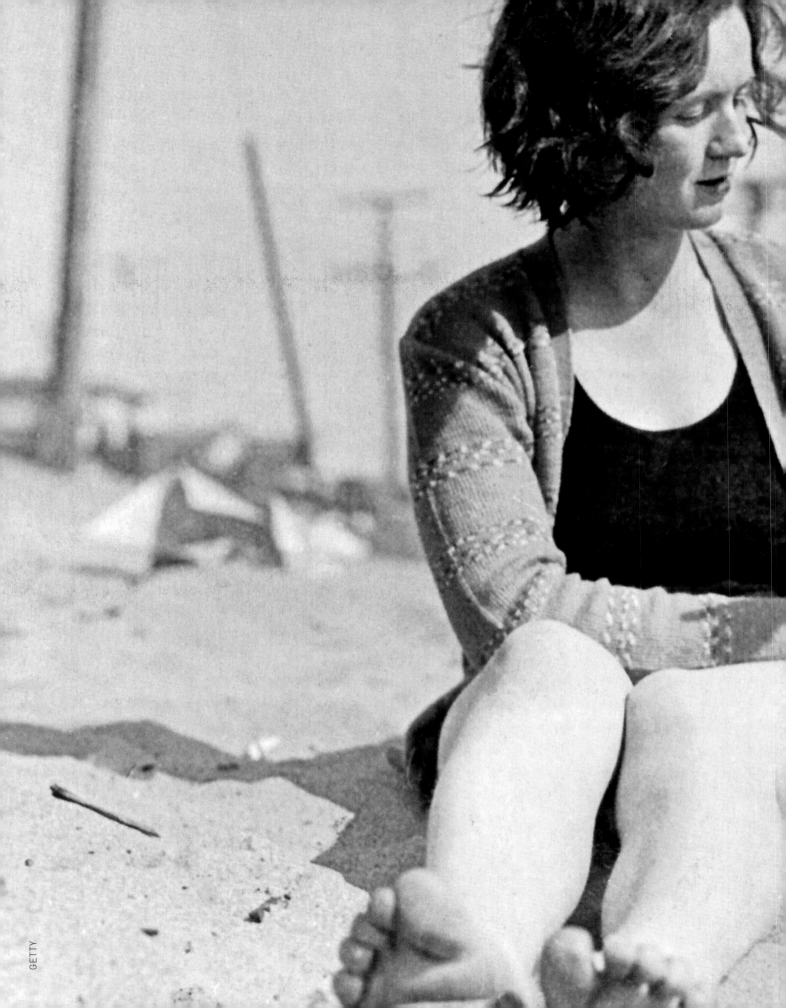

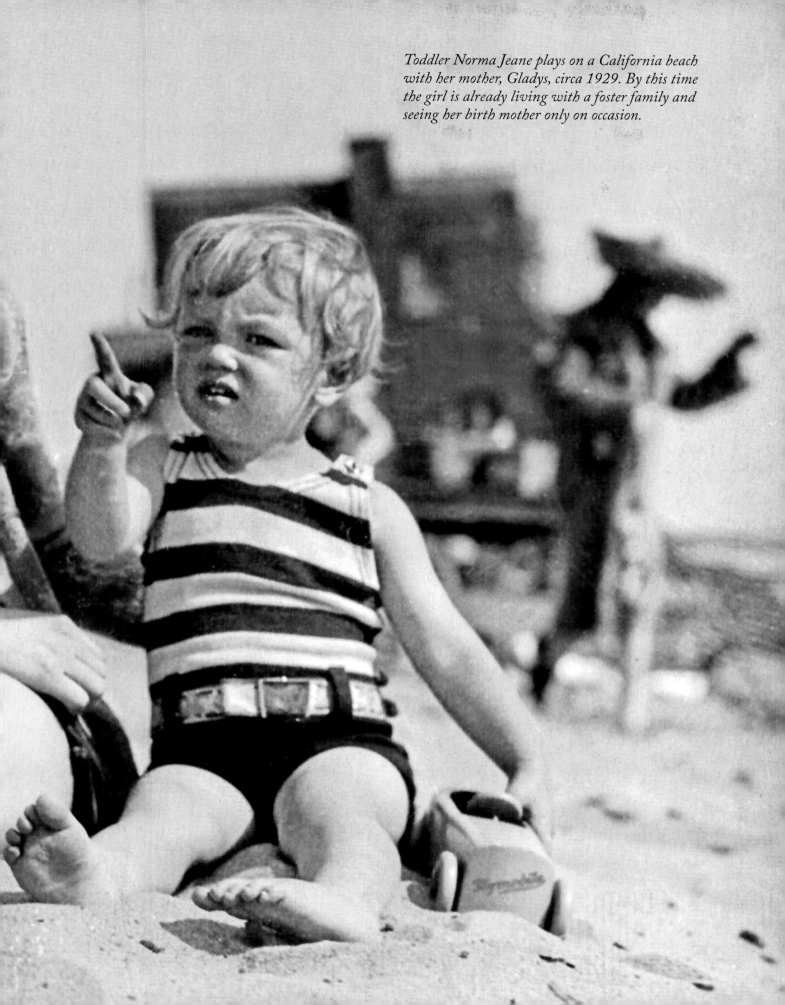

Toddler Norma Jeane plays on a California beach with her mother, Gladys, circa 1929. By this time the girl is already living with a foster family and seeing her birth mother only on occasion.

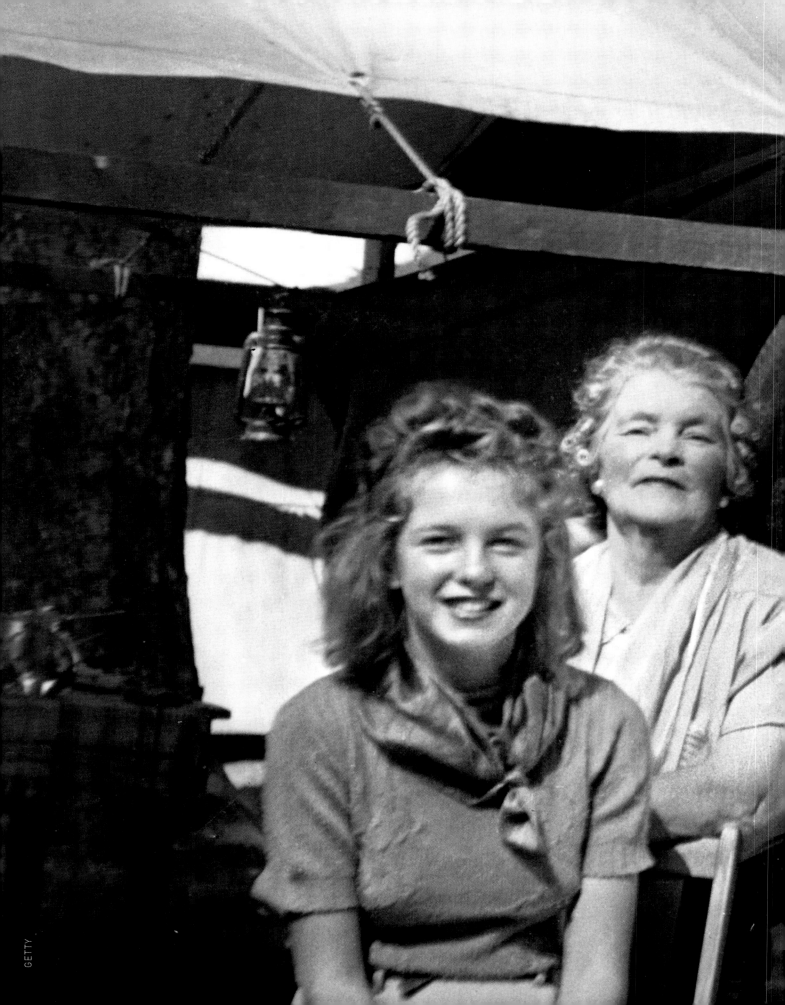

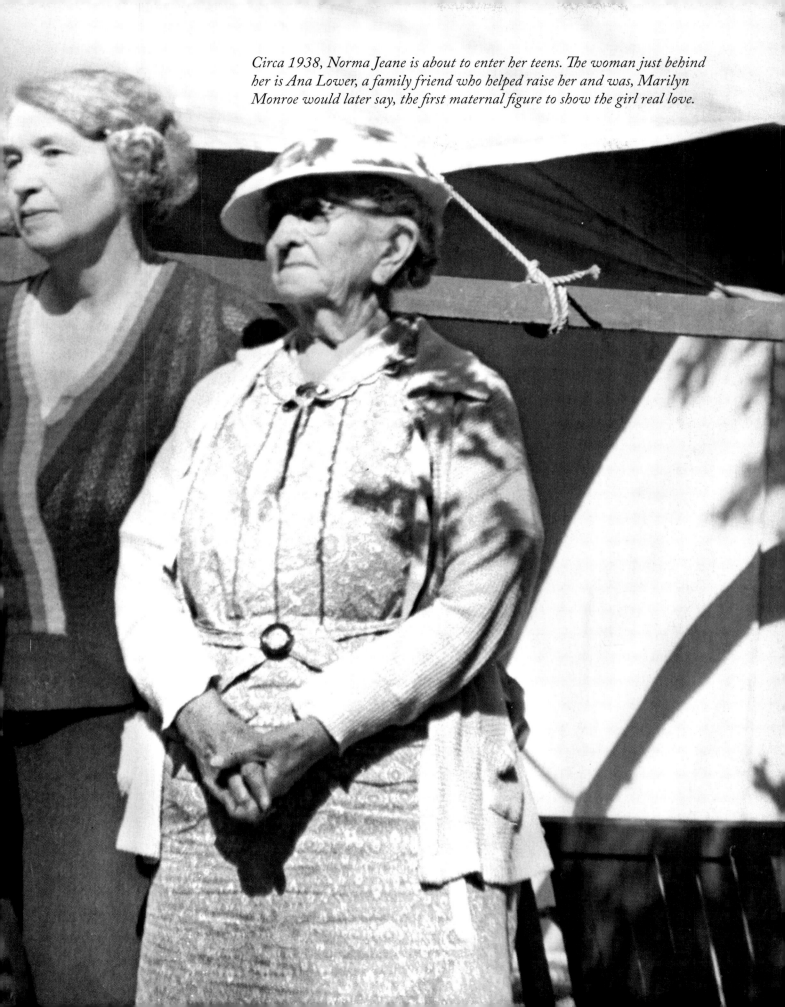

Circa 1938, Norma Jeane is about to enter her teens. The woman just behind her is Ana Lower, a family friend who helped raise her and was, Marilyn Monroe would later say, the first maternal figure to show the girl real love.

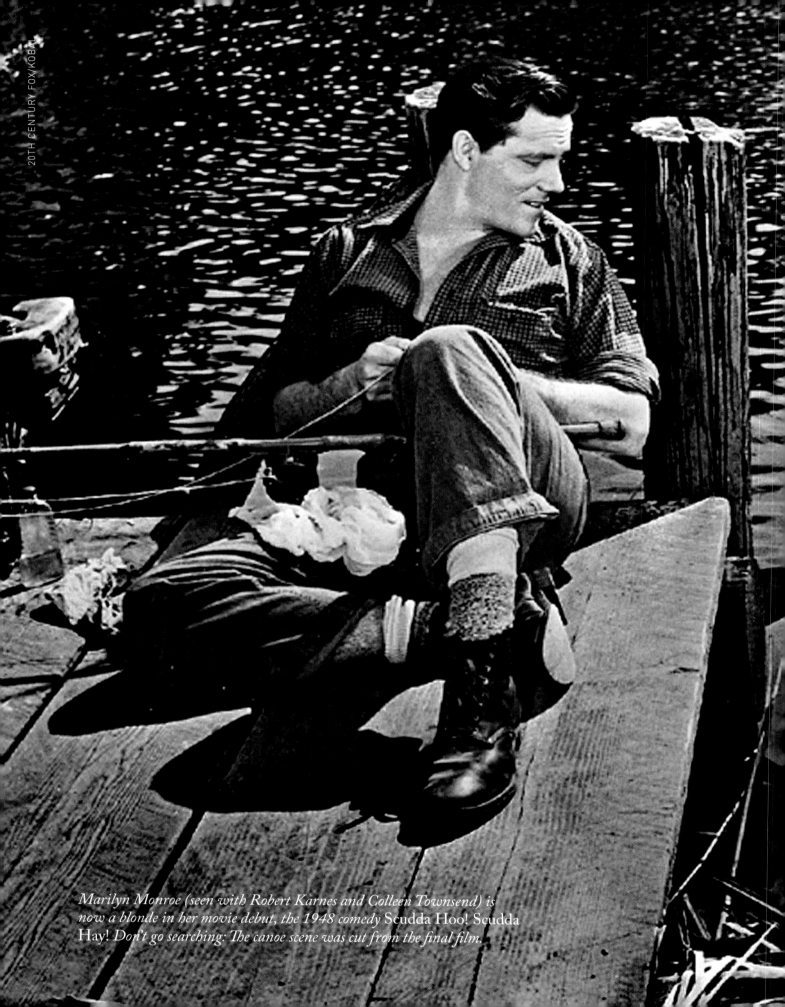

Marilyn Monroe (seen with Robert Karnes and Colleen Townsend) is now a blonde in her movie debut, the 1948 comedy Scudda Hoo! Scudda Hay! *Don't go searching: The canoe scene was cut from the final film.*

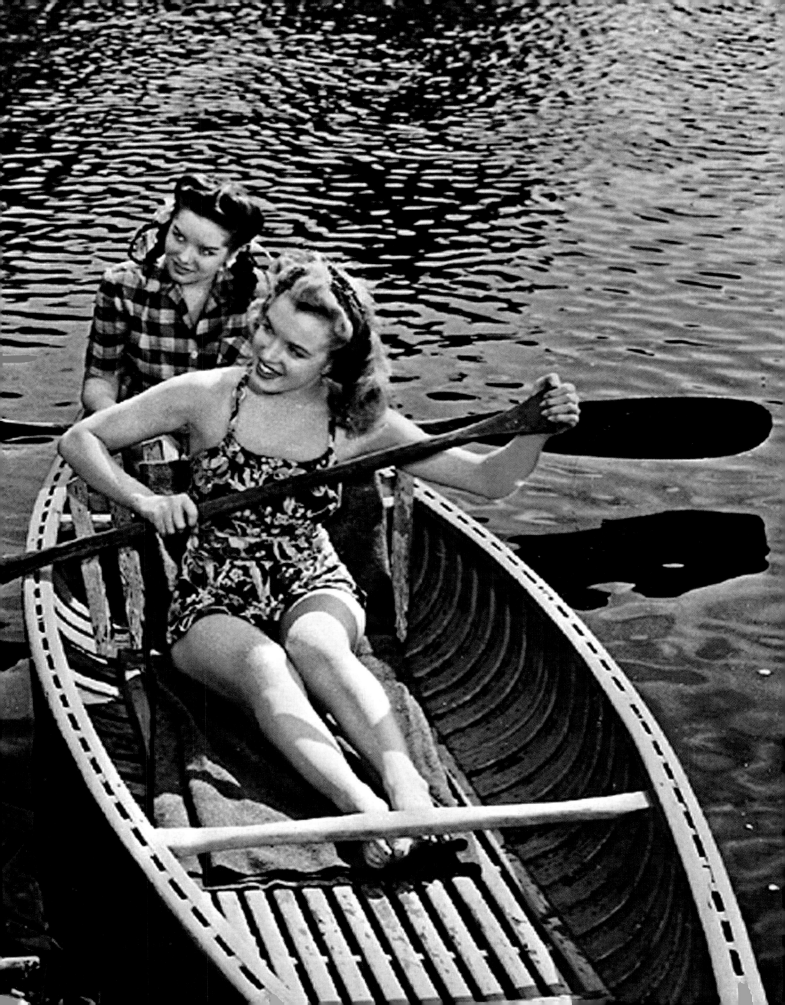

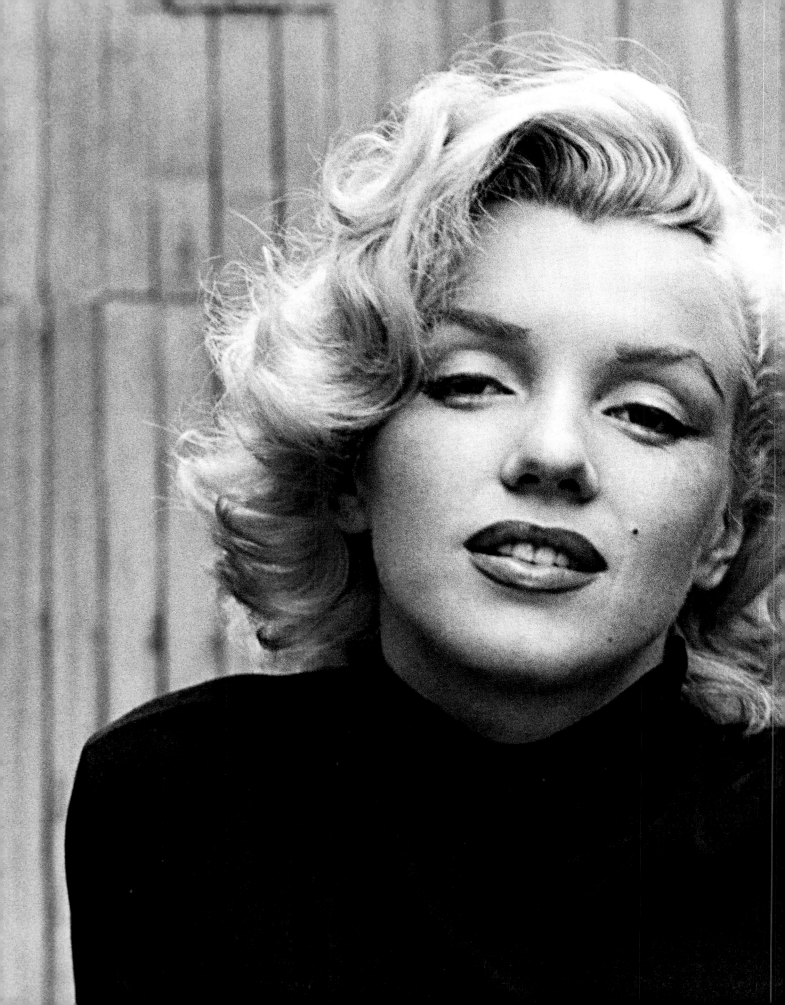

In 1953, the actress poses on the patio of her
Hollywood home for the camera of famed LIFE
photographer Alfred Eisenstaedt.

Newlyweds Arthur Miller and Marilyn Monroe embrace in the summer of 1956.

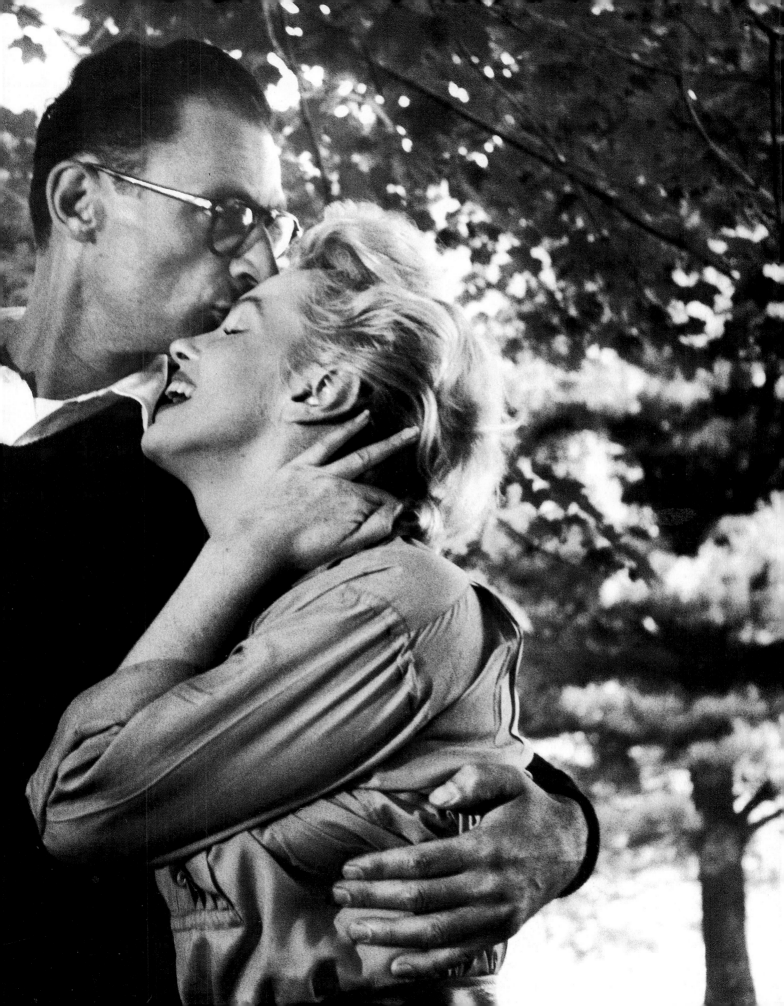

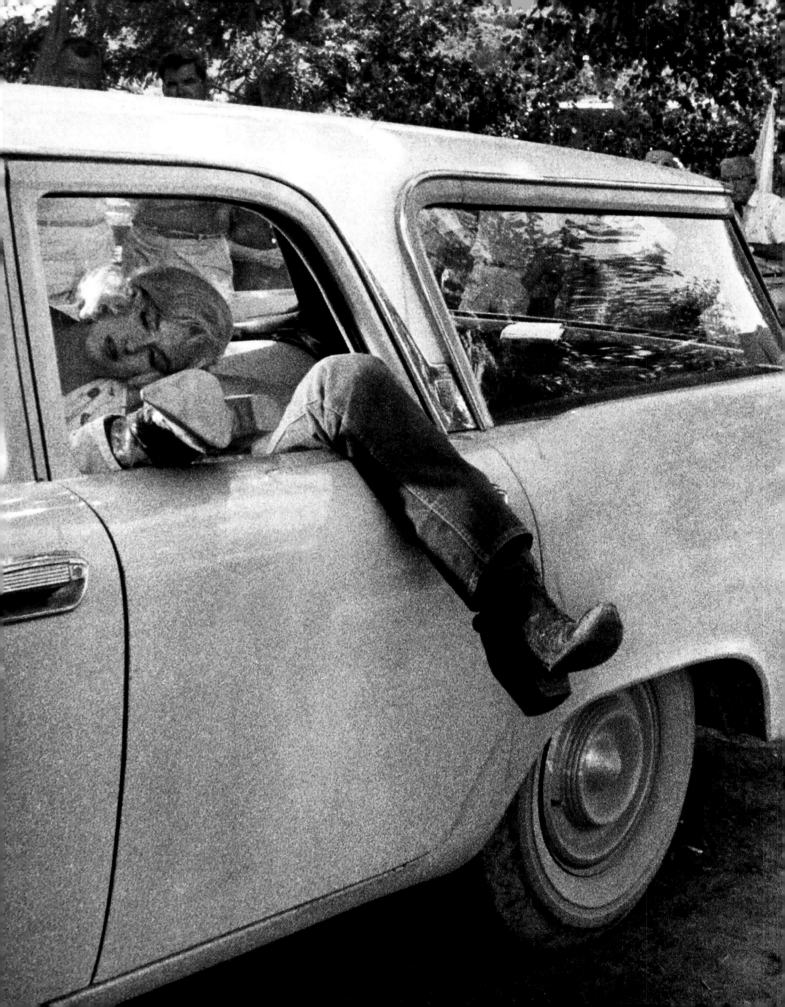

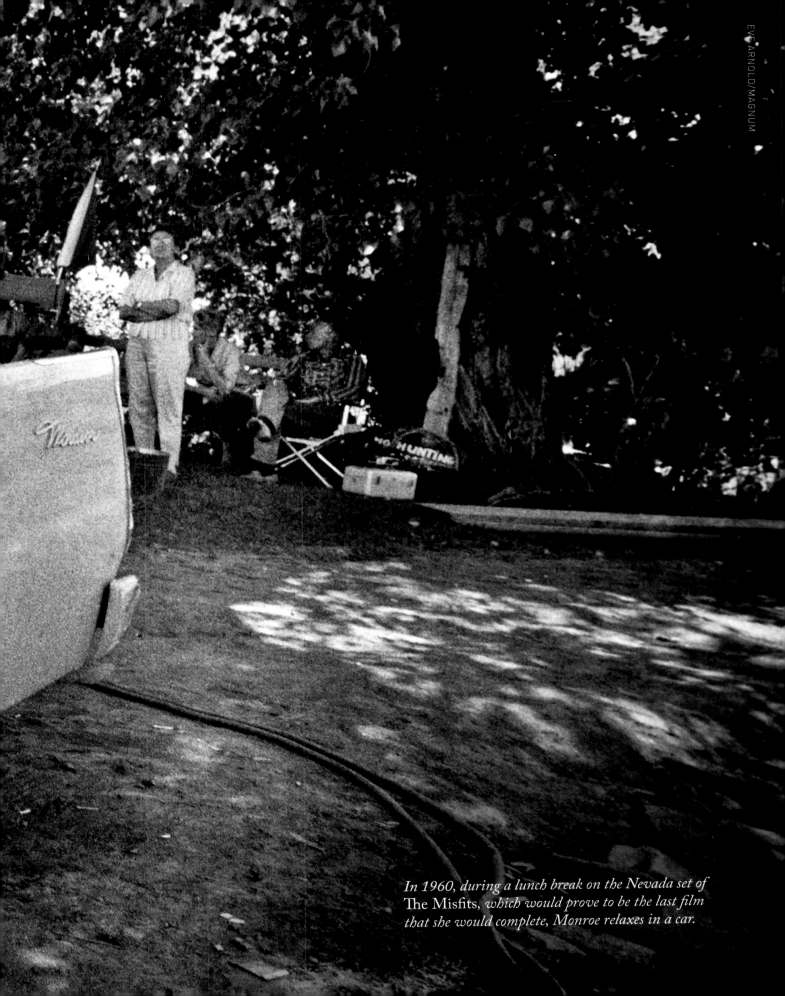

In 1960, during a lunch break on the Nevada set of
The Misfits, *which would prove to be the last film
that she would complete, Monroe relaxes in a car.*

Marilyn and Myth

The term *screen legend* has been applied to Marilyn Monroe perhaps more often than to any other star in the vast Hollywood firmament. That is proper, for *legend* implies a story not only larger than life but also in some ways unbelievable.

Chapters in her biography are certainly that. Even after the life story of Marilyn Monroe has been retold a thousand times, we are not absolutely sure which parts are precisely true and which are not, what really happened and what did not, what is fact and what is hyperbole or even fiction. Monroe willingly contributed to the legend herself; just as one example, she certainly pumped up the woebegone-orphan aspect of her childhood. And studio publicists were only too happy to heap on enough additional baloney to satisfy the hungriest lunchtime patrons at Schwab's. Some episodes that have clung stubbornly to the Marilyn Monroe narrative like so many barnacles are about as real as the color of her platinum blonde hair.

To look at the end of the tale here at the beginning, let's consider her death: At age 36 in 1962, Marilyn Monroe died in what the coroner ruled was a "probable" suicide. Many of her fans insist it was an accidental drug overdose, while many others hold that it was murder, and a subset is sure the Kennedys were involved. They say there are tape recordings, made by the FBI or a private detective hired by someone else, that prove this.

Let's look at her marriages, which together represent another biographical item that you would think we would have a firm handle on by now. We know there were three: The first was an affair either strictly of convenience or at least somewhat of the heart, depending on whom you

believe; the second involved a baseball star; the third was to an esteemed playwright. But some people say there was a fourth, and even the most often cited biographies don't agree on this.

Some film fans think that biographer Anthony Summers came closest to the true Marilyn. Some side with Donald Spoto, some with Barbara Leaming, some with Fred Lawrence Guiles. Some say that Norman Mailer captured her best in his impressionistic rendering.

Our purpose in these pages is not to settle the matter; such an effort would prove futile. We will in our text and captions present the facts as they are known to be true and allude to the controversies as they crop up. We will be as accurate as possible.

More important, in keeping with LIFE's tradition and mission, we will present a beguiling and intimate photographic biography of this singular, beautiful, spirited, unfailingly generous and endlessly compelling movie star. We are, in one way, in a fortunate position: Although people sometimes lie, pictures don't. In these pages, Norma Jeane Mortensen Baker (Marilyn) Monroe, as she lived her life day to day from infancy until death, is reborn. As you gaze at these pictures and look into Marilyn's eyes, you are seeing her—the happiness, the sadness, the joy, the sorrow. You are reliving a life and spending time with the very real woman beyond the myth.

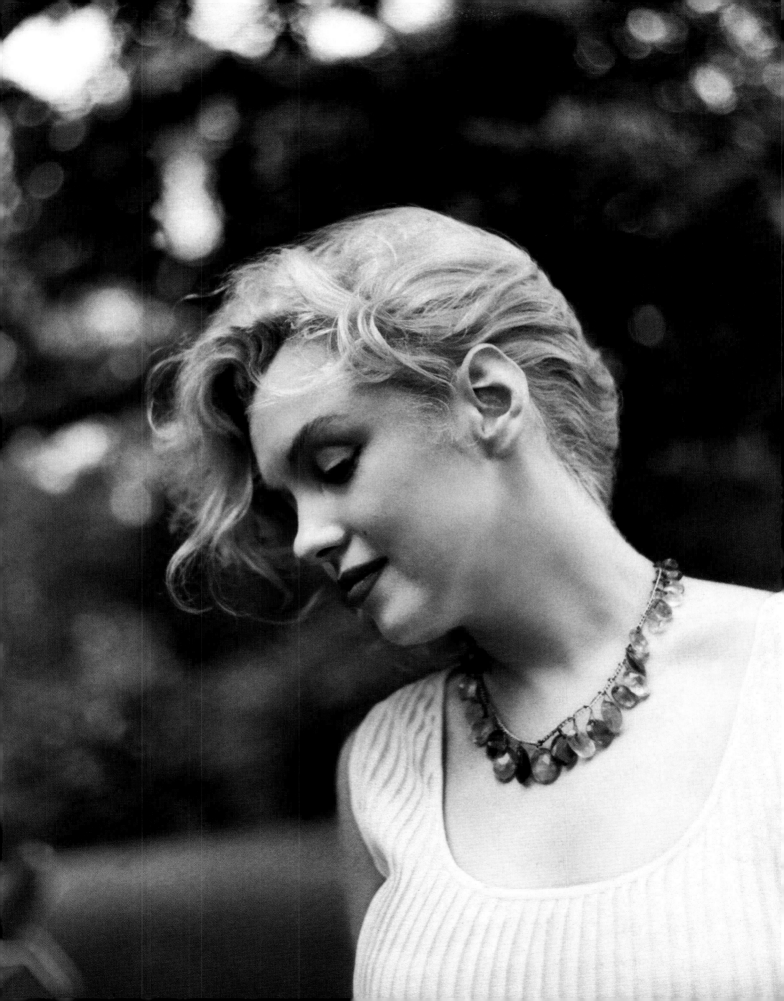

Norma Jeane

Her story is hazy from the first and involves at the outset a troubled mother and an absent father. Gladys Monroe, who would give birth to Norma Jeane at Los Angeles General Hospital on June 1, 1926, was herself the product of an unstable home. She was born in 1902 and, as a little girl,

witnessed the mental erosion of her father when syphilis attacked his brain and sent him to the hospital, where he died, according to Donald Spoto's *Marilyn Monroe: The Biography*. Gladys was thereafter raised by a mother who would eventually suffer from hallucinations and display erratic behavior, perhaps similarly caused by a physical malady. Gladys married for the first time at age 14; this husband, Jasper Newton "Jap" Baker, was more than a decade her senior. Together they would have two children, a boy called Jackie and a girl named Berniece. After Gladys divorced Jap, he kidnapped the kids and took them to his native state, Kentucky, to raise them. Jackie would die young, and Berniece would not see her mother again for 20 years.

Gladys then married Martin Edward Mortensen in 1924; she left him in early 1925, and their divorce was finalized in 1928. The question of who Norma Jeane's dad was is one that still lingers. Although it is unlikely that Mortensen was her father—Marilyn Monroe said she always imagined another man, whose photograph was once shown to her by her mother, as her father—Gladys had the surname Mortenson written in on Norma Jeane's birth certificate, compounding the confusion by misspelling it. Then, on Norma Jeane's baptismal certificate, Gladys gave her

child the surname of her first husband, Baker.

Therefore: Norma Jeane Mortensen Baker, who would one day take her mother's maiden name and alliteratively become Marilyn Monroe.

By the time Norma Jeane was born on that summer morning in 1926, Gladys was working in a lab cutting film negatives. There she befriended a co-worker, Grace McKee, and together, according to biographer Spoto, they earned reputations as risqué, fun-loving flappers of the Roaring '20s. Gladys, realizing that she was unable to appropriately care for her baby, within two weeks turned her over to a foster home—that of Albert and Ida Bolender, who, in Marilyn Monroe's later recollection, were caring if stern and pious churchgoers. The couple took in a steady trickle of foster children for the extra income. Though Norma Jeane would see her birth mother on occasion, it would be 12 years, she would later say, before she ever felt loved.

Testimony from the Bolender house, where Norma Jeane spent her first seven years, differs with this sad account, asserting that Norma

The infant Norma Jeane is about six months old in this photograph. She is by now being raised by her first foster parents, the Bolenders, in Hawthorne, California.

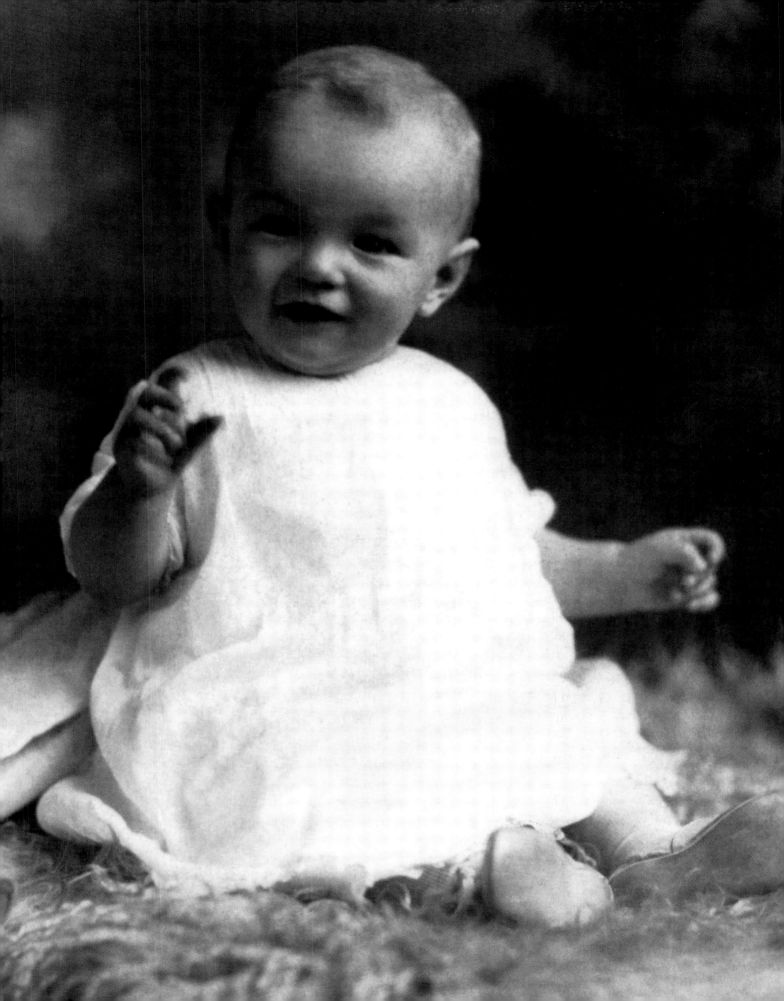

Norma Jeane

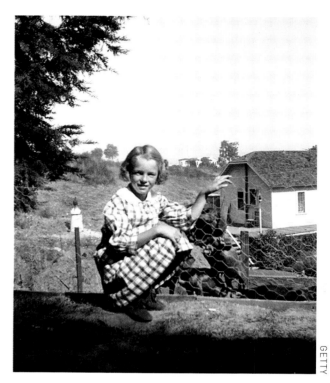

This picture was taken circa 1933. At about this time, when Norma Jeane is seven, she leaves the Bolender home and moves back in with her mother.

Jeane was a happy little girl, and this contradiction provides us with a very early example of how the true story of Marilyn Monroe will always be elusive. The movie queen told a reporter in the early 1950s that the past was "an unpleasant experience I'm trying to forget," and in many other tellings, the record of Norma Jeane's youth has her bouncing among foster homes like a ping-pong ball. The semiofficial version surely represents a creative blending of fact and fiction by Hollywood publicists—and by Monroe herself, including the version she coauthored in her posthumously published memoir, *My Story.* As her close friend columnist Sidney Skolsky once wrote: "She was not quite the poor waif she claimed to have been." Skolsky noted that the number of foster homes seemed to multiply as time went on because "she knew it was a good selling point."

Whatever the precise details of Norma Jeane's early years, they could not have been cheerful and carefree, and they certainly lacked the influence of a nurturing parent. In fact, confusion has to have been a dominant theme of her upbringing. The Bolenders would drill into Norma Jeane that going to the movies was a burnable sin; later, Gladys and Grace would entice her with the glamour and escape of the silver screen. Gladys would spend time with her daughter at the beach, and she must have shown some maternal affection. But their relationship was sufficiently distant that for a time little Norma Jeane knew her only as "the woman with the red hair."

There was one attempt at a formal mother-and-child reunion. In 1933, Norma Jeane left the Bolenders to live again with Gladys, but the mother suffered a nervous breakdown that year—Monroe later said she had watched as Gladys, screaming and laughing, was taken by force from the house—and Grace McKee stepped in to oversee the little girl's care. When Grace married Ervin Goddard in 1935, Norma Jeane, then nine, was sent to the Los Angeles Orphans Home, where she would spend up to two years (accounts differ); stints at other foster homes would follow. As for the mother's fate: Gladys would spend many of her remaining years in hospitals and institutions, dying in a nursing home in 1984. She and Norma Jeane would remain virtual strangers, but the daughter, as soon as she was able, always saw to it—even in her will—that money was set aside for her mother's care.

Grace McKee (now Grace Goddard), who formally became Norma Jeane's legal guardian in 1937—taking the 11-year-old back into her own home—would prove an immense influence. She sought to fashion the child after her favorite film

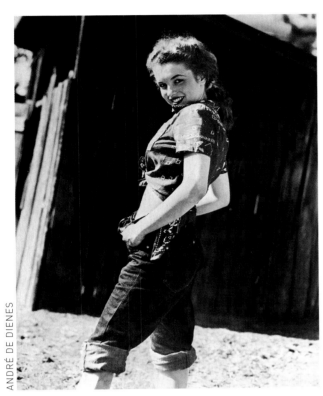

Norma Jeane in her teens. She is, in this period, being tossed tumultuously between various foster homes and then into an arranged marriage.

star, the blonde bombshell Jean Harlow. Grace taught Norma Jeane how to apply makeup; she took her to have her hair curled. For her part, Norma Jeane bought in willingly, avidly; at one point, she measured her hands and feet against the imprints of screen idols outside Grauman's Chinese Theatre. Even at the orphanage, before she moved back in with Grace, Norma Jeane, her head full of dreams of stardom, found solace in the sight of the nearby RKO studios water tower—a reminder of Grace and Gladys, a totem of a thrilling existence on the horizon.

Into a young life already brimful with tumult now came serious trauma. A short time after Norma Jeane became part of his household, Ervin Goddard, Grace's husband, allegedly tried to molest her. The girl was then sent to live with her great aunt Ida Martin. There, at age 11, she was sexually assaulted by a cousin, according to biographer Spoto. Marilyn Monroe herself, in her memoir, talked of an earlier attack, when she was eight. Norma Jeane was ushered further down the line to the care of Grace's aunt Ana Lower, and there she would finally find a safe harbor. This was where the girl who "felt like I was on the outside of the world" for the first time felt the warmth of love from—and for—her guardian.

Norma Jeane faced another change as she entered adolescence. The unremarkable-looking girl who in school had been taunted as "Norma Jeane the String Bean" quickly developed curves that threatened the seams of her clothes. New nicknames would come; an early favorite of the boys, Spoto writes, was "the Mmmm Girl." Marilyn Monroe would later whimsically recall, "The world became friendly."

In 1942, however, the 15-year-old Norma Jeane found the world turning less friendly again. Ana Lower was stricken with health problems, and Norma Jeane once more returned to Grace's care, but now Ervin, the household's breadwinner, was being relocated to West Virginia. Norma Jeane was informed that the family wasn't going to take her with them. Since her legal custodian was leaving California, Norma Jeane was faced with a possible return to the orphanage. (Some accounts say she did go back briefly.) Yet Grace presented her with a means of escape. She had already been playing matchmaker between Norma Jeane and a friend's son, Jim Dougherty,

Norma Jeane

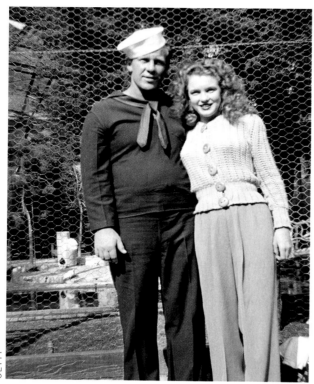

GETTY

She is a teenage bride alongside first husband James Dougherty in this photograph taken in California circa 1943.

who was five years older. Now, Grace proposed, the two should get married as soon as Norma Jeane turned 16. Failing that, the girl would have to live in the orphanage until she reached 18.

Norma Jeane made her decision and wed Dougherty in June of 1942.

Dougherty would later say there had been love in the relationship, but Monroe would remember things differently. "There's not much to say about it," she once recalled of the situation. "They [the Goddards] couldn't support me, and they had to work out something. And so I got married." She wrote in *My Story* that she never felt much like a wife in that first marriage and that her principal

enjoyment at the time continued to come from playing with kids in the neighborhood. The marriage was destined to last four years.

During that period, in 1943, Jim joined the merchant marine and, after being briefly stationed on heavenly Santa Catalina Island, off the California coast, was shipped overseas in 1944. Norma Jeane moved in with Jim's mother and did her part for the war effort at the Radioplane Company, where she spent long days spraying varnish and folding parachutes.

As it is in so many Hollywood sagas, the story of Mrs. Norma Jeane Dougherty's being discovered and taking her first step toward becoming Marilyn Monroe—the lucky break, the critical meeting—came down to the right place and the right time. Army photographer David Conover was always on the lookout for attractive Rosie the Riveters to brighten his stories for military magazines, and the brunette Norma Jeane was attractive indeed. So much so that after photographing her, Conover suggested she try modeling and told her about the Blue Book agency. Norma Jeane took the tip, signed with Blue Book and in relatively short order became one of the firm's top models. When someone said she might be even more successful as a blonde, the compliant Norma Jeane accepted this suggestion, too, and bleached her hair.

In 1945, she left the defense factory, determined to make the most of her breakthrough in modeling—a decision that displeased Jim Dougherty and served to hasten the end of their already-fragile marriage. She posed for advertisements and magazine covers but also artsy shoots with photographers like André de Dienes,

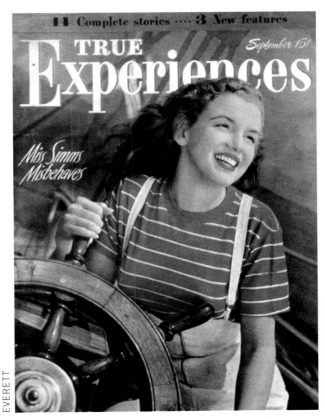

In 1945, Norma Jeane Dougherty begins her modeling career and starts popping up on the covers of all manner of magazines.

with whom she had a brief affair (among others in this time period, perhaps). She worked seminude for pinup artist Earl Moran, who later recalled: "She liked to pose. For her it was acting." Of her talent in this regard, he added that she was "better than anyone else."

That's indisputably true. Throughout her modeling and film career, she continued to have a special rapport with the lens of a still camera. At the speed of a shutter blink, she leaped to life, displaying a verve all her own and, at the end of the process, connected magnetically with the eyes of the viewer. Even the earliest photographers—and she would eventually be shot by many of the very best—found her skillful, discerning, cooperative, imaginative and utterly bewitching. In posing for the still camera, she exhibited none of the anxieties or neuroses that would haunt her movie career. And the photos captured over her lifetime are iconic in their own right—as much a part of the legacy of Marilyn Monroe as her film work.

In the summer of 1946, while in the midst of her divorce from Jim Dougherty, Norma Jeane, who had been brought to the attention of Twentieth Century-Fox recruiter Ben Lyon, was given a screen test. Those in attendance were unanimously impressed. "It's Jean Harlow all over again," said Lyon.

"I got a cold chill," cinematographer Leon Shamroy told *Collier's*. "This girl had something I hadn't seen since silent pictures . . . Every frame of the test radiated sex. She didn't need a sound track—she was creating effects visually."

The audition won Norma Jeane a six-month contract. She was also given a new name. She and Lyon stitched together her mother's maiden name (Norma Jeane's suggestion) and the first name of actress Marilyn Miller (whom Lyon felt this aspirant starlet called to mind).

And so it was, in a phrase Elton John would sing poignantly decades later, goodbye, Norma Jeane. And hello, Marilyn Monroe.

It is clear, in reviewing the tangled and often tormented early years of this woman, that none of the biography we have thus far recounted would be remembered by anyone today had this transformation not occurred. Who would have bothered to put the narrative together? She was thoroughly inconsequential. Just another unfortunate product of a brutally fractured home who was facing life without a high school degree and, barely 20, with a failed marriage.

But she had been found by Hollywood. She had been plucked; she had been chosen.

At the time, it surely looked like her salvation.

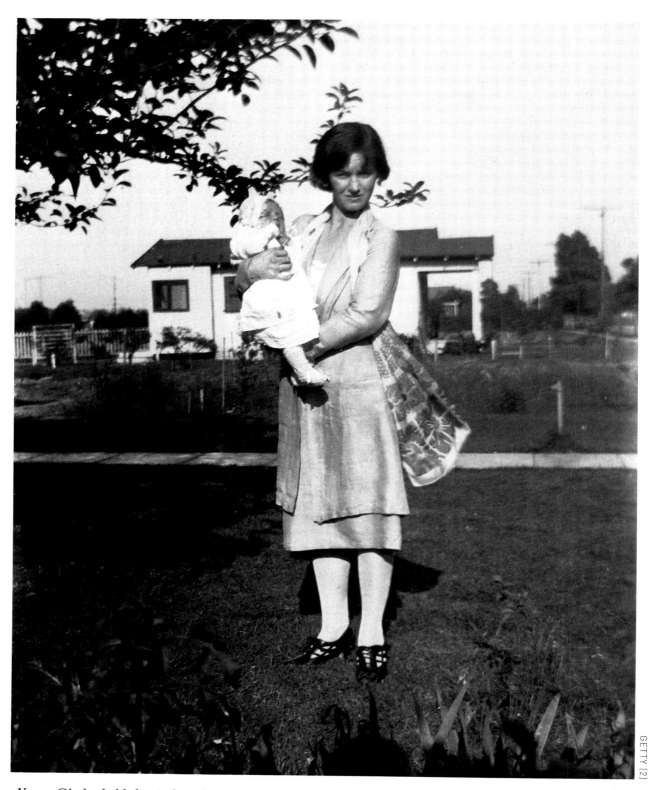

Above: Gladys holds her infant daughter, Norma Jeane, in 1926. Whether or not Edward Mortensen was the girl's father, he did not file for divorce from Gladys until the following spring, and so the baby was not an illegitimate child as has sometimes been rumored. Opposite: Norma Jeane at the age of two. For understandable reasons, as a very young girl she thought that the Bolenders, who were raising her, were her real parents. It was Ida Bolender who eventually got Norma Jeane to understand the painful truth.

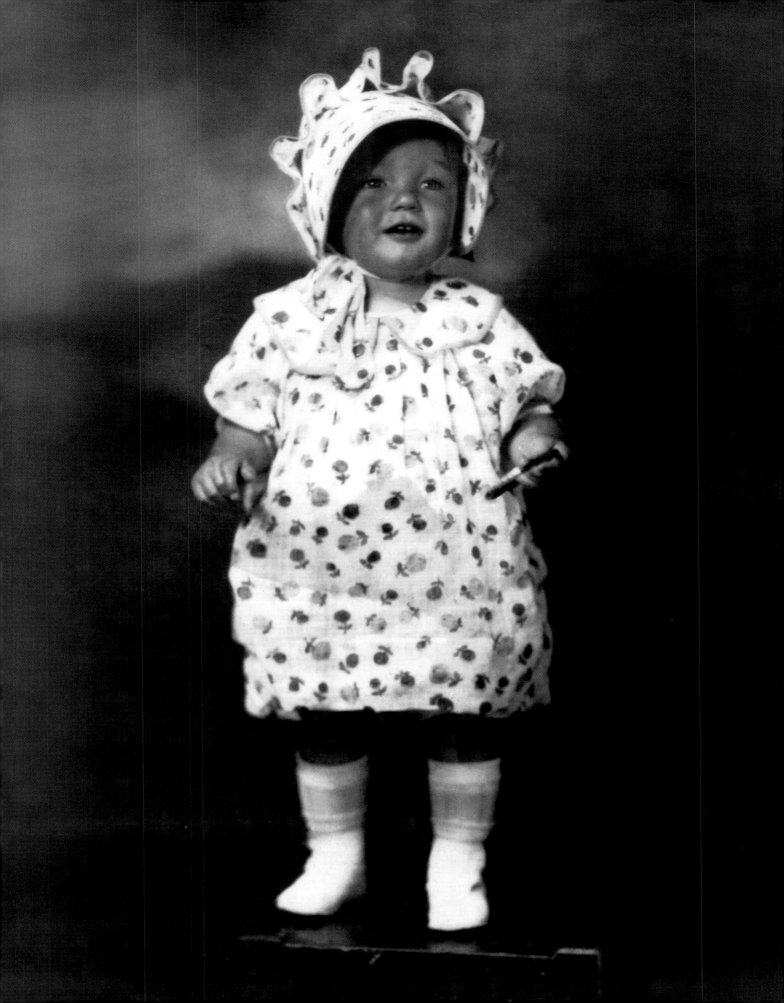

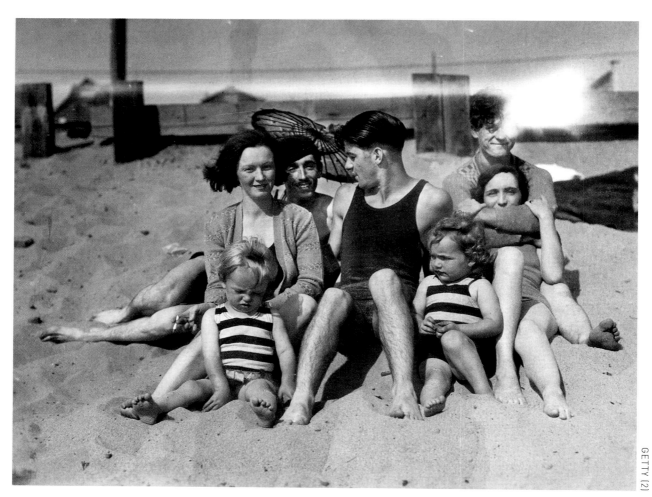

The photograph at the beach, above, was taken circa 1929, and Norma Jeane, the little girl at left, is about three years old. Gladys sits behind her. The friends are unidentified, but the mood conveyed by the picture reflects the carefree social scene in which Gladys and her friend Grace McKee traveled in the 1920s. Opposite: Norma Jeane poses with two younger friends and a birthday cake at about the age of 10. Her fate during this period is particularly troubled as she is in and out of the orphanage and then, worse still, becomes the victim of an attempted molestation by Grace McKee's husband, Ervin Goddard.

In the picture on the pages immediately following, taken circa 1941, Norma Jeane is in the center of a group of friends at about age 15. She has by now suffered another physical assault and is only a year away from leaving school and marrying for the first time.

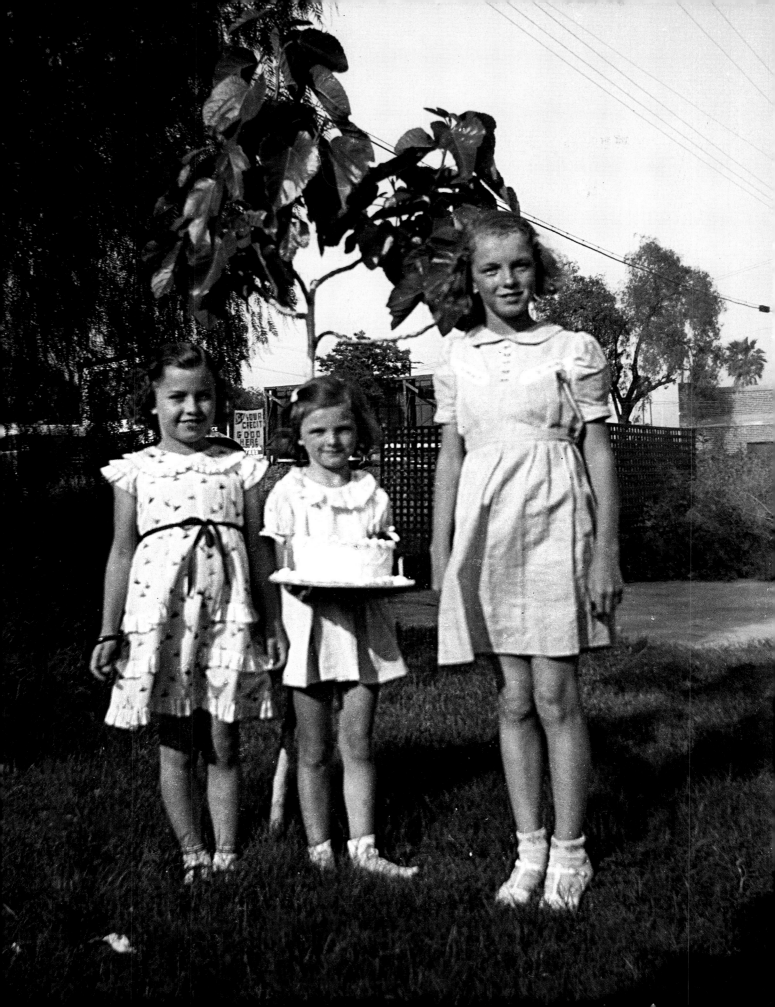

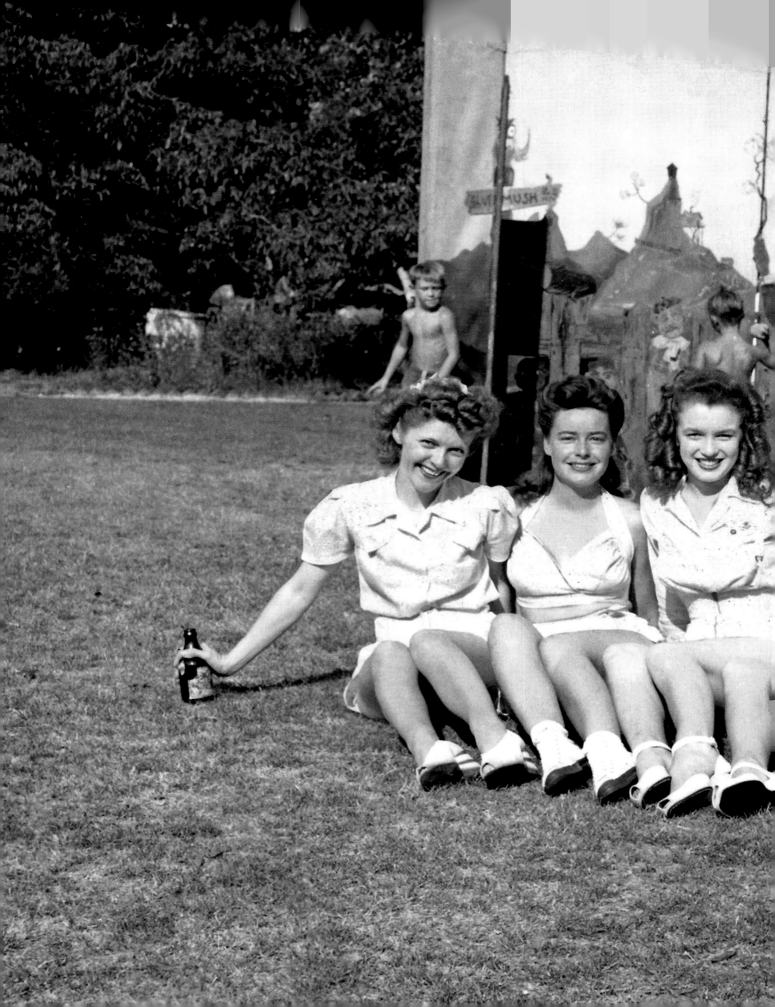

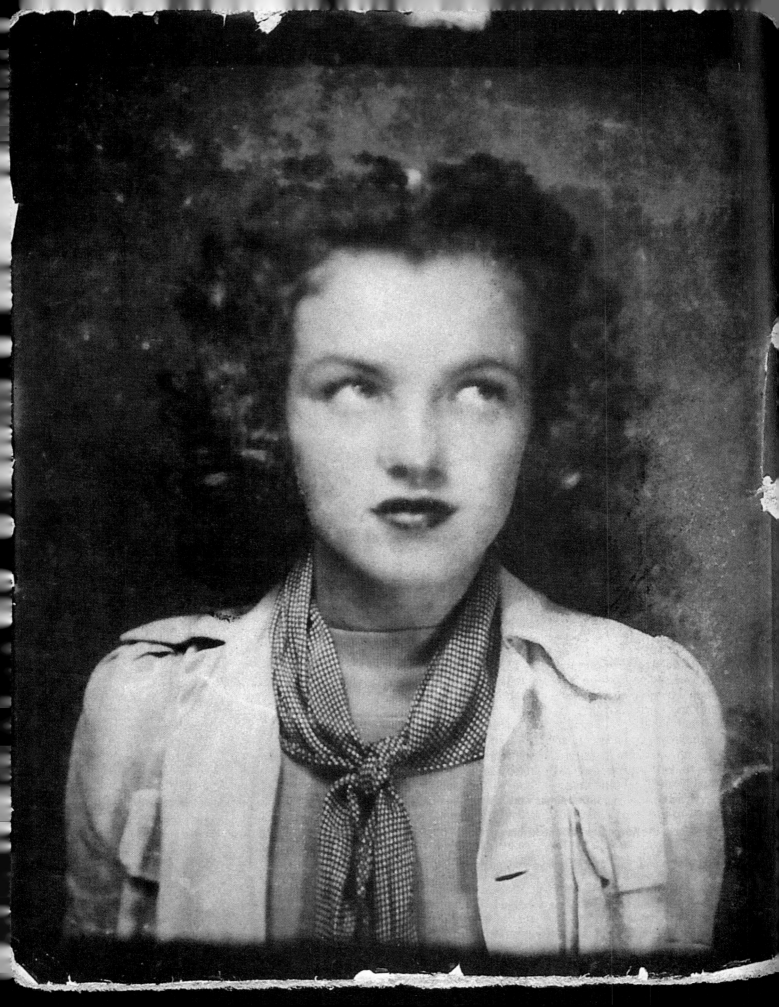

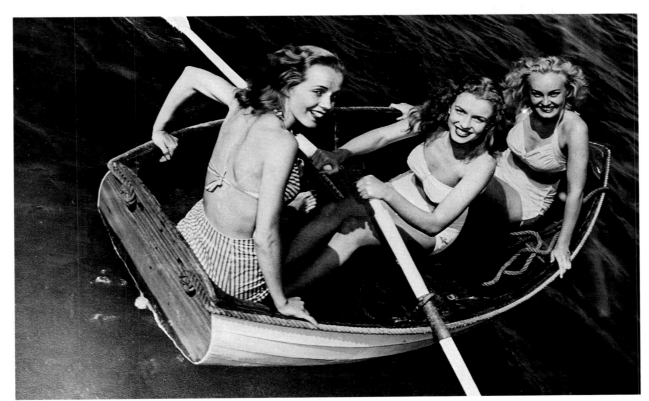

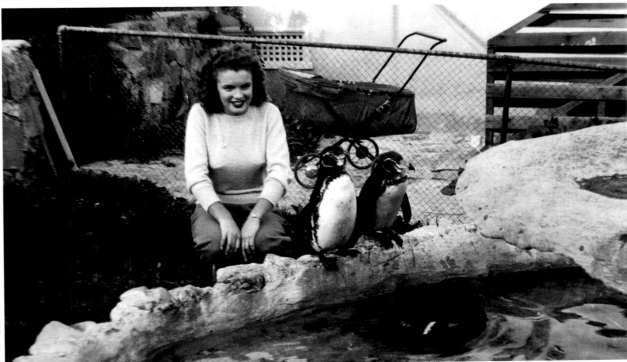

These three photographs—the portrait on the opposite page, the picture at top of Norma Jeane (center) rowing with two unnamed friends and the photo of her playing with three unnamed penguins—were all made in the late 1930s and early '40s. The pretty adolescent obviously favored this particular portrait, for she sent it to her older half sister, Berniece Baker, when she learned of Berniece's existence in 1938. They finally met in 1944 in Detroit, where Berniece had moved after growing up in Kentucky with her father, Gladys Monroe's first husband, Jasper Baker. Berniece told LIFE in 1994 that the two women loved each other instantly and remained close thereafter. She was remembered in Marilyn Monroe's will, receiving $10,000.

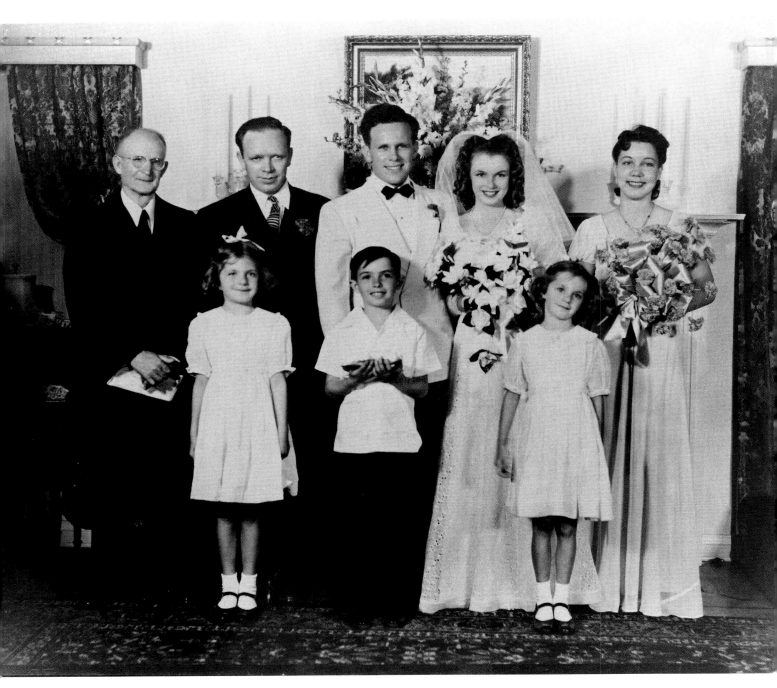

Above: In June of 1942, James Dougherty and Norma Jeane Baker wed in California, the bride having recently turned 16. Opposite: In a picture probably taken sometime the following year, Norma Jeane poses on Avalon Beach on Santa Catalina Island, where her husband is stationed at the merchant marine boot camp. (The storied Casino can be seen in the background.) The Doughertys would not be physically together much longer, as Jim would be shipped overseas; they would eventually divorce in 1946. By that time, Norma Jeane would be busy with her modeling career, an enterprise that by most accounts did not sit well with Dougherty. He would later write two books about their relationship, The Secret Happiness of Marilyn Monroe *and* To Norma Jeane With Love, Jimmie, *and at one point, he would appear on the TV show* To Tell the Truth *as "Marilyn Monroe's real first husband."*

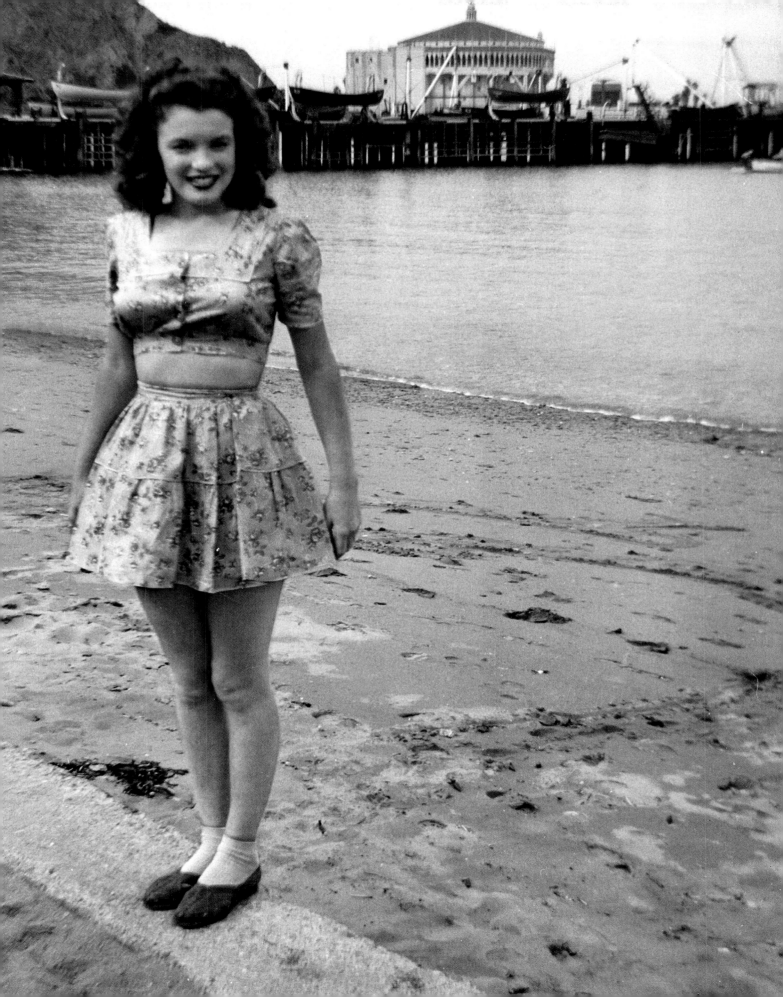

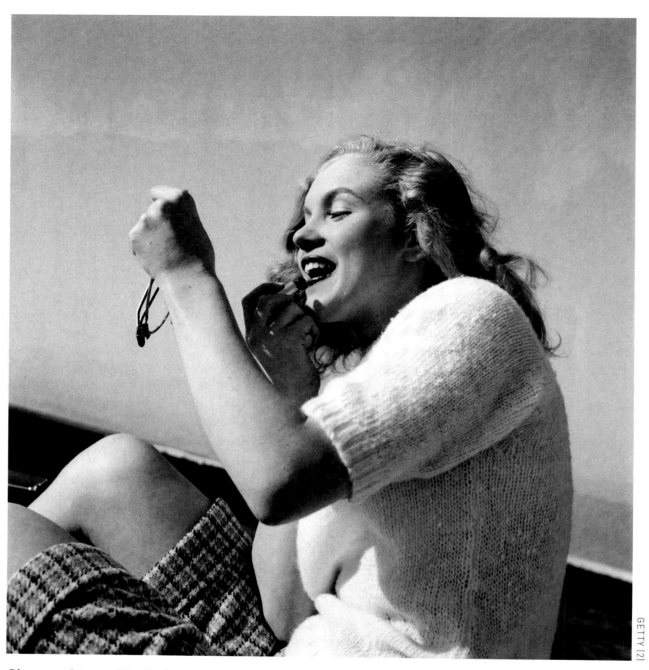

She seemed incapable of taking a bad picture, as these images from the mid-1940s, plus the two on the pages immediately following (taken at Castle Rock State Park in July 1945), prove. Her voluptuous figure and five-foot-five-and-a-half-inch stature were not well suited for fashion photography but were perfect for the kind of cheesecake pictures that were on display in a plethora of pinup or exploitation magazines popular at the time. Earl Moran, who employed Marilyn regularly as a model for calendar and magazine illustrations, once said of her, "She knew exactly what to do. Her movements, her hands, her body were just perfect. She was the sexiest. Better than anyone else. Emotionally, she did everything right. She expressed just what I wanted." But what Marilyn wanted was to be an actress, not just a model: "I used to think, as I looked out on the Hollywood night, 'There must be thousands of girls sitting alone like me, dreaming of becoming a movie star. But I'm not going to worry about them. I'm dreaming the hardest.'" Her dreams would soon come true.

Marilyn

Emmeline Snively, who ran the modeling agency that employed Norma Jeane Dougherty, commented years later that girls would often ask her how they could be more like the woman who had become Marilyn Monroe. "I tell them,

if they showed one tenth of the hard work and gumption that that girl had, they'd be on their way. But there will never be another like her."

While that is no doubt true, Monroe's singularity wasn't immediately apparent to Twentieth Century-Fox's filmmakers, who used her for small parts in a couple of forgettable vehicles, *Scudda Hoo! Scudda Hay!* and *Dangerous Years*, both filmed in 1947. After one year, Fox declined to renew Monroe's contract. She signed a six-month deal with Columbia Pictures and was given a big role in a bad film, the low-budget musical *Ladies of the Chorus*. In that 1949 movie, Monroe first displayed her velvety singing voice—to the precious few patrons who bought a ticket. Columbia, too, opted not to extend her contract, but her association with the studio would have lasting benefits, since it brought her into contact with the noted drama instructor Natasha Lytess, who would continue to coach her for several years.

For a time, Monroe was forced to resort to one-picture agreements as well as a renewed emphasis on her modeling career. She may have resorted to something else as well during these early years. Just as her various biographers differ in their conclusions regarding any casting-couch liaisons and in their speculations as to how many abortions Monroe may have undergone in her lifetime (more than a dozen, by one count; none, according to the actress's

former gynecologist), they are not of one mind about whether Monroe, in the lean years, prostituted herself. She may well have; one former friend told biographer Donald Spoto that Monroe had bartered sex on Hollywood's side streets in exchange for meals. She was barely 20 at the time, very much on her own, and surely desperate to make ends meet.

The limitless sexuality that would be such a hallmark of Monroe's persona was openly acknowledged in one of her earliest films, the Marx Brothers' *Love Happy*. When Monroe appears in the doorway of Sam Grunion's detective agency, a male character's monocle pops out and a billow of smoke whistles from his pipe like steam from a kettle.

"Some men are following me," Monroe breathes to the detective Grunion, played by Groucho.

"Really?" he says, as he watches his prospective client sashay about. "I can't understand why."

Monroe's part in the movie was only a small one, but she made enough of an impression on

In the 1950s, LIFE was the country's preeminent picture magazine and Monroe was Hollywood's most photogenic movie star, and therefore many famous LIFE shooters—Eisenstaedt, Clark, Halsman, Greene—came calling. Opposite is a 1956 portrait by Gordon Parks.

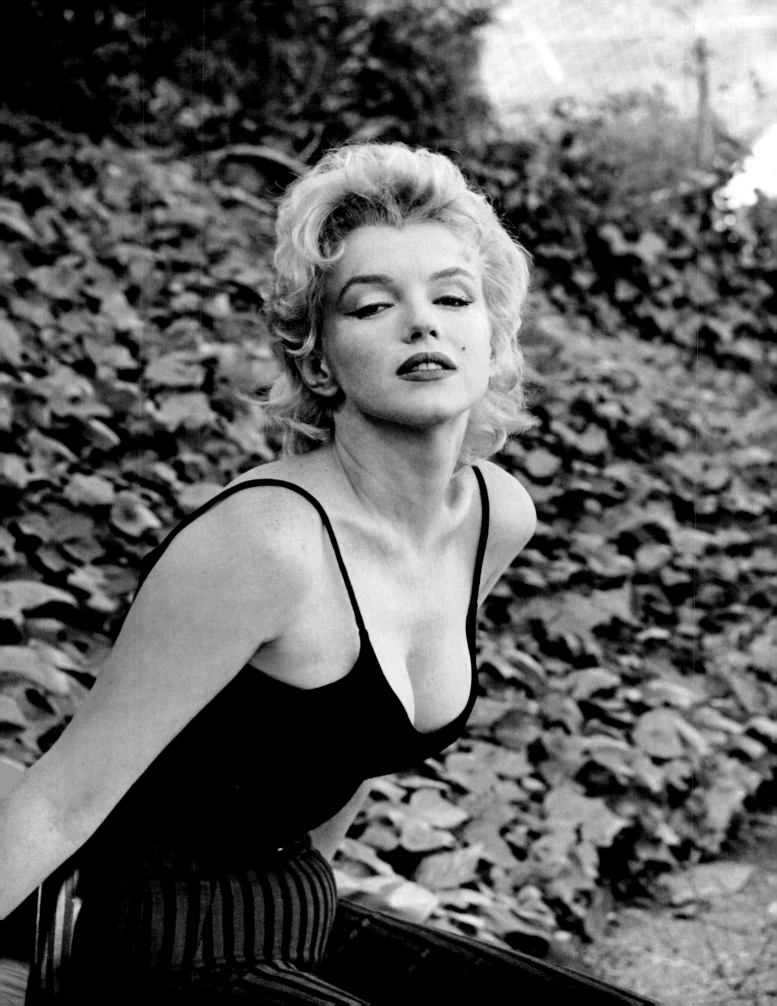

Marilyn

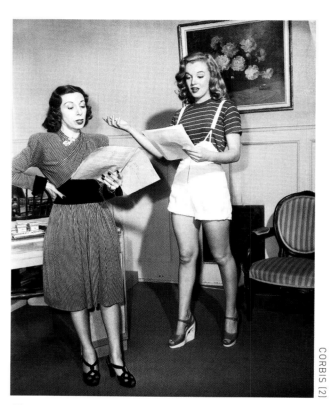

First you have to learn how to do it: In 1947, the freshly renamed Marilyn Monroe practices her acting chops under the tutelage of coach Helena Sorell.

the producers at United Artists, one of whom was the legendary actress Mary Pickford, that they sent her, for $100 a week, to help promote the movie in New York and other cities ahead of its release in the spring of 1950. In that same year, two much bigger and more serious-minded pictures by heavyweight directors were released, each of which featured Monroe in a minor role. When John Huston's *The Asphalt Jungle* and Joseph L. Mankiewicz's Oscar-winning *All About Eve* followed on the heels of *Love Happy*, a buzz began to build about this young actress who could play funny, play dramatic and always play beautiful. In 1951, the ascendant Monroe returned to Fox, where this time she signed a seven-year contract promising her a steady income of $500 a week, with yearly increases that could push the weekly pay as high as $3,500. She appeared first in a string of B movies and then, in 1952, drew some praise for her comedic performance in *Monkey Business*, which starred Cary Grant and Ginger Rogers, and her dramatic turns in *Clash by Night*, which starred Barbara Stanwyck, and the thriller *Don't Bother to Knock*, in which Monroe herself played the lead. We say "some praise" because acceptance by the public came well before acceptance by the entertainment press.

Whatever the critics' opinions of her talent, Monroe was now on the fast track to stardom. Thousands of fan letters were arriving each week, and across the land there was, according to a 1952 article in *Time* magazine, a "loud, sustained wolf whistle" emanating from the doors of the nation's barbershops and garages. That whistle, accompanied by howls of outrage from

some sectors, grew positively deafening when a decision that Monroe had made came back to haunt her. In 1949, the struggling actress had posed nude for a calendar for $50. Now, in 1952, Fox executives were hearing rumors that the extravagantly naked blonde in the ubiquitous pinup shot—a shot that would gain even wider currency the following year when it was selected as the first Sweetheart of the Month centerfold in the debut issue of *Playboy* magazine—was none other than their young starlet. In addressing the brewing scandal with a reporter from the United Press wire service, Monroe exhibited a disarming cheerfulness that played well with her public. "Why deny it? You can get one anyplace," Monroe said of the calendar. "Besides, I'm not ashamed of it. I've done nothing wrong."

Right you are, agreed a majority of moviegoers, with an overwhelming majority of the yeasayers being male. All men desired her, and suddenly one of the most famous ones seemed

to be on the verge of landing her. Right around the time of the brouhaha over the nude photo, Monroe went on her first date with the recently retired baseball deity Joe DiMaggio. She arrived two hours late but assuaged the erstwhile Yankee Clipper with a bon mot: "There's a blue polka dot exactly in the middle of your tie knot. Did it take you long to fix it like that?" How do we know these intimate details? Well, because

Next you get to strut your stuff: In 1948, performing in the Columbia film Ladies of the Chorus, *Monroe sings two songs, including, here, "Every Baby Needs a Da-Da-Daddy."*

Hollywood's press departments (not to mention the stars themselves) didn't miss a trick in quickly disseminating social items (real or fabricated) that might enhance or elevate an actor's public image. In fact, one of Monroe's biographers, Barbara Leaming, suggests that the liaison with DiMaggio was a calculated PR move to deflect attention from the naked-pix controversy,

though most other chroniclers take the advent of the Marilyn-and-Joe relationship at face value.

We cannot doubt that Monroe was capable of coming up with that playful witticism spontaneously and without help from Fox's marketers. In public appearances and with the press, she showed a quick, dry wit, as well as a willingness to have sport with her obvious sexual allure. When asked whether she really had nothing on in the calendar spread, she answered, "I had the radio on." Asked what she wore to bed nightly, she replied coquettishly, "Chanel No. 5." Reporters loved this stuff and led the applause. *Time* called her "a saucy, hip-swinging 5 ft. 5½ in. personality who has brought back to the movies the kind of unbridled sex appeal that has been missing since the days of Clara Bow and Jean Harlow." The Los Angeles Press Club presented her at one point with its annual Miss Press Club award.

And that was only one of the earliest prizes and titles to come her way. Between 1951 and 1953, Monroe was named Miss Cheesecake of 1951, by *The Stars and Stripes* newspaper; the Present All GIs Would Like to Find in Their Christmas Stocking, by voting members of the armed services; World Film Favorite, by members of the Hollywood foreign press; the Girl Most Likely to Thaw Alaska, by soldiers stationed in the Aleutians; the Girl Most Wanted to Examine, by the

Marilyn

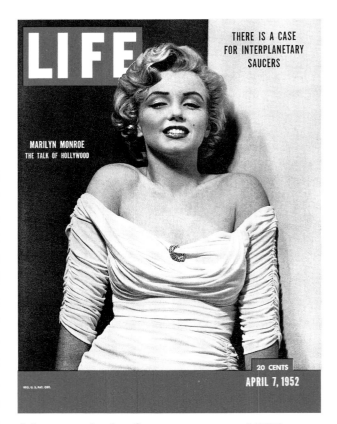

7th Division Medical Corps; the Girl They Would Most Like to Intercept, by All Weather Fighter Squadron Three of San Diego; Cheesecake Queen of 1952, again by *The Stars and Stripes*; the Most Promising Female Newcomer of 1952, by *Look* magazine; the Most Advertised Girl in the World 1953, by the Advertising Association of the West; the Fastest Rising Star of 1952, by *Photoplay* magazine; the Best Young Box Office Personality, by *Redbook* magazine; and the Best Friend a Diamond Ever Had, by the Jewelry Academy. Her first appearance on the cover of LIFE came on April 7, 1952: a Philippe Halsman portrait with the simple cover line THE TALK OF HOLLYWOOD.

All of this acclaim and attention was nice, of course, but still the name Marilyn Monroe was rarely, if ever, mentioned in connection with the biggest award of all—the Oscar. That situation would slowly change as the 1950s progressed. In the 1953 noir film *Niagara,* Monroe electrified audiences if not critics with her portrayal of Rose Loomis, an adulterous wife who plots her husband's murder. Her quiet, smoldering rendition of the song "Kiss" and an extended shot of her wavering caboose as she ambled away from the camera—regarded as "the longest walk in movie history"—were takeaway memories. *The New York Times* wrote, "Obviously ignoring the idea that there are Seven Wonders of the World, Twentieth Century-Fox has discovered two more and enhanced them with Technicolor in *Niagara* . . . For the producers are making full use of both the grandeur of the Falls and its adjacent areas as well as the grandeur that is Marilyn Monroe."

Her very next film to be released was

Monroe makes her first appearance on LIFE's cover in the spring of 1952. It will not be her last; in fact, there will be 10 more.

Gentlemen Prefer Blondes, directed by Howard Hawks, and it altered the course of her career. A musical comedy about two showgirls, it featured Monroe (alongside Jane Russell) as the vapid, wide-eyed Lorelei Lee, a money-seeking missile whom men nonetheless find irresistible. This movie, too, showcased Monroe's vocals, particularly in what would become for her a signature song, "Diamonds Are a Girl's Best Friend." In a shift from several of Monroe's earlier roles, Lorelei had a defanged sexiness; a clever woman, she purposely behaved as a dim bulb because, she believed slyly, men preferred women that way. Monroe's nimble performance helped make the film a hit, but it also served to typecast the actress as Lorelei—not necessarily an off-the-mark assessment. Many of Monroe's co-workers and friends were always saying that she was no dumb blonde and that there were depths to her personality that were unknown to

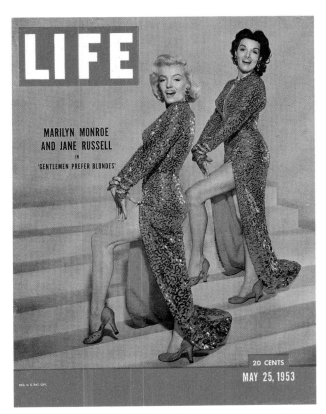

Her next cover comes the following year and is shared with fellow glamour queen Jane Russell, her costar in Gentlemen Prefer Blondes.

the public. "Lorelei, like Marilyn, begs the question of how much is a performance, how much is natural," Sarah Churchwell writes in *The Many Lives of Marilyn Monroe*. "What is she *really* like?"

Even if Monroe was a real-life Lorelei, creating that character—or any character—onscreen was no easy task. Her difficulties on movie sets were legion, the polar opposite of the ease she showed in front of a still camera. She once said of how she agonized to get things right, "I've always felt toward the slightest scene, even if all I had to do in a scene was just to come in and say, 'Hi,' that the people ought to get their money's worth

and that this is an obligation of mine, to give them the best you can get from me." Also, Monroe, who described herself to *The Saturday Evening Post* as "a mixture of simplicity and complexes," was never able to leave her anxieties at the office. She suffered from crippling insomnia, then worried in turn that she would appear tired on film. She began taking sedatives at night and, some biographers say, amphetamines to counter any next-day drowsiness caused by the sedatives. She would sometimes break out in blotches or suffer fits of vomiting before reporting for work. She earned a reputation for tardiness. "A lot of people can be there on time and do nothing," Monroe said, but it was a shallow defense.

She became known for demanding retake after retake, until she or her drama coach, whose presence on the set was anathema to directors, was satisfied. In an article on one of her productions, LIFE reported that the crew resorted to playing along with the retakes without film in the camera.

She got away with all of it. Why? Because the producers and directors were often rewarded with a fine performance. And also because many of them liked her. She was known to be gracious to colleagues, the type who would (and did) give money to crew members who, she had heard, had a sick spouse or were mourning the loss of a loved one. She was no self-indulgent diva on the set but an anguished woman trying her best.

"She is not malicious. She is not temperamental. She is a star—a self-illuminating body, an original, a legend," said Jerry Wald, a producer of *Let's Make Love*, for which, LIFE wrote, the star's delays in 1960 carried a

Marilyn

$1 million price tag. "You hire a legend and it's going to cost you dough."

Said Jack Cole, a dance instructor who worked with Monroe: "She is always looking for more time—a hem out of line, a mussed hair, a scene to discuss, anything to stall facing the specter, the terrible thing of doing something for which she feels inadequate . . .

"She wants to do it like it's never been done before."

She once said: "I used to get the feeling, and sometimes I still get it, that sometimes I was fooling somebody. I don't know who or what—maybe myself."

In a variation on that theme, she told *The New York Times* in July 1953, the month *Gentlemen Prefer Blondes* hit the theaters: "I feel as though it's all happening to someone right next to me. I'm close—I can feel it, I can hear it—but it isn't really me."

Who was she really, as she became this superstar? Apparently she didn't know, and certainly the public didn't. To her fans, she was the golden one, the beautiful girlfriend of Joltin' Joe DiMaggio, the screen goddess who somehow, with her wit and charm, was approachable. Who was *real*.

Some biographies claim Monroe was leading such a double life during this period that she even managed a secret marriage, which to this day cannot be proved. In one version of events, a writer named Robert Slatzer competed for her affection with DiMaggio in 1952, and on October 4 he and Monroe, having had drinks at the Foreign Club in Tijuana, Mexico, decided impulsively to wed. They found a lawyer who performed the ceremony, but once back in California, Monroe had a change of heart, perhaps with some urging from Twentieth Century-Fox head Darryl F. Zanuck, and wanted out. She and Slatzer went back to Mexico and paid off the lawyer to erase all evidence of the marriage. And that was that: a three-day union. Is the story true? Slatzer, who wrote two books about Monroe and died in 2005, always said it was. There's room enough for doubt, though, and the biographers are divided.

So behind the scenes such events may or may not have taken place, while before the flashbulbs, in the summer of 1953, the actress

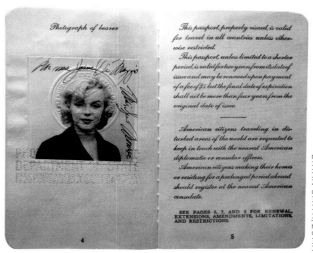

BRYAN SMITH/ZUMA

Norma Jeane Baker could only dream of such things as international travel, but Norma Jeane DiMaggio (note signature!) needs a passport—not least because she is soon to honeymoon in Japan.

pressed her hands and high heels into wet cement outside Grauman's Chinese Theatre, no longer little Norma Jeane measuring herself against the imprints of others but Marilyn Monroe, living out the dream.

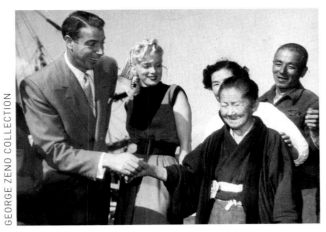

Newlyweds DiMaggio and Monroe are all smiles in Tokyo on January 14, 1954. DiMaggio's smile will fade shortly thereafter when his wife takes a detour to South Korea.

She clearly knew how large her stardom had become and knew just as well that she was being underpaid by Fox—for *Gentlemen Prefer Blondes*, she earned a tenth of costar Jane Russell's take, according to biographer Spoto—and she felt undervalued by the world at large. "I want to grow and develop and play serious dramatic parts," Monroe told *The New York Times* in July 1953. "My dramatic coach, Natasha Lytess, tells everybody that I have great soul—but so far nobody's interested in it. Someday, though, someday."

Monroe decided to try to take her fate back into her own hands. She had her agent press the studio to negotiate a new contract with better pay and, more important, creative control of her career; she wanted the right to refuse assignments or, at least, to pick some of her on-set collaborators, including directors. Meantime, she balked when Fox ordered her in mid-December of 1953 to report to the set of *The Girl in Pink Tights*, just the kind of movie Monroe was loath to make at that time. She instead jetted off to meet DiMaggio in San Francisco for Christmas. When she failed to report yet again, after the studio had pushed back the start date to early January, Fox suspended her.

In the midst of all this, DiMaggio proposed marriage, and on January 14, 1954, he and Monroe were wed in a three-minute ceremony at City Hall in San Francisco. According to Spoto, Marilyn turned to Joe at one point and asked if, were she to die before him, he would adorn her grave with flowers each week, as William Powell had done for Jean Harlow. Joe promised her that he would.

The newlyweds flew to Japan, where pandemonium attended their honeymoon as fans craned to see the baseball hero and, as one Japanese radio broadcaster put it, "the honorable buttocks-swinging actress." The wild attention, abroad as well as at home, coupled with the public's infatuation with his sexy wife, would very quickly prey upon the private, intensely jealous DiMaggio. He had been hoping Monroe would trade stardom for a settled-down life at home—a home that would be far from Hollywood. But her stardom was at its apex while his was in eclipse, and DiMaggio's desires, it quickly became apparent, would not be fulfilled.

While in Japan, Monroe was offered an opportunity to entertain tens of thousands of American servicemen during a four-day tour of South Korea, and she seized the chance. Throughout her career, she took particular pride in appealing to the everyman—being recognized by a dog walker or a garbage collector—and feeling like she gave their day a boost. She would do the same now for these troops.

And so a bare-shouldered Monroe braved February temperatures to put on a series of honeymoon shows before roaring audiences of salivating American GIs.

"It was so wonderful, Joe," Monroe reported back excitedly. "You never heard such cheering."

Marilyn

"Yes," her husband replied quietly. "I have."

Back in the U.S., Monroe at last returned to work in the spring of '54. Fox had certainly heard her complaints, was renegotiating her contract and had agreed not to force *Pink Tights* on her if she instead took a role in the musical *There's No Business Like Show Business*. As a plum, she would be given a starring role in director Billy Wilder's *The Seven Year Itch*.

Although (and in many ways, *because*) Monroe's career was getting back on track, her marriage was quickly eroding. DiMaggio wasn't enjoying life in L.A.; he would spend much of the day watching TV. He could be withdrawn and distant, and there were times, Monroe later said, when he would go days on end without speaking to her. He also continued to be greatly unnerved by Monroe's stardom, and there is speculation in some of the biographies that this strong former athlete was violent with her.

The frayed knot of their marriage finally snapped in mid-September 1954 while Monroe was in New York City to shoot parts of *The Seven Year Itch*. One of the on-location scenes had Monroe perched over a subway grate as a gust from below lifted her white skirt like a cloud. For hours, a mob of people jammed the city street corner, cheering her on and illuminating the night with a storm of popping flashbulbs. Among the crowd was a furious Joe DiMaggio.

It is widely held that a nasty hotel-room argument ensued, and by some accounts there were bruises on Monroe's shoulders or back the next day. Whether or not DiMaggio beat her that night, Monroe returned to Los Angeles and, within three weeks, filed for a divorce. At the proceedings, she told the judge that the nine-month marriage had been "mostly one of coldness and indifference." And with that, it was ended.

A first footnote on the dissolution of this famous relationship: The skirt stunt that finished things off was just that—a stunt. It wasn't an actual shoot but a publicity gimmick, a way to drum up interest and entice audiences. The footage that actually appeared in the movie was shot later on a soundstage in Hollywood.

And a second footnote: The failure of their brief marriage deeply affected both DiMaggio and Monroe, and although the two were no longer legally bound to each other, they would remain emotionally tied. DiMaggio readily swooped in at a moment's notice whenever Monroe needed him. He would remain loyal to her in the last years of her brief life—and then, after her death.

By the end of 1954, it became clear to Monroe that the studio, while making nice, was not going to cede much in the way of creative control. She found a loophole in her contract that under her interpretation freed her from Fox. She left Hollywood for New York City, where she would spend a busy year in an earnest effort to improve her artistry and prove herself worthy of critical acclaim. Meanwhile, in early January of 1955, she and Milton Greene, an A-list photographer who had shot pictures of her in the early days, was briefly romantically involved with her and advised her on business matters, announced the formation of Marilyn Monroe Productions Inc. She was "tired of the same old sex roles," Monroe said at the unveiling of her

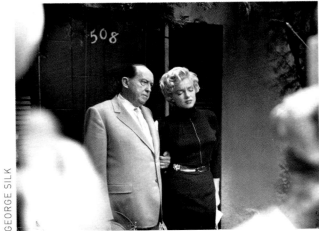

In September 1954, Monroe strikes sexy poses in New York City during filming of The Seven Year Itch—*too many such poses for her husband's taste. Very soon after returning to L.A., she is accompanied by her lawyer Jerry Giesler after filing for a divorce from DiMaggio.*

new company. "People have scope, you know."

Three days after the debut of MMP, Monroe was back in L.A. to put the finishing touches on *The Seven Year Itch*. "You're looking good," Billy Wilder reportedly told her.

"Why shouldn't I?" she replied. "I'm incorporated!"

The MMP gambit would, Monroe hoped, allow her to leverage her box office performance with the studio; she figured, not incorrectly, that Fox needed her as much as she needed Fox. But more than stardom or money, what Monroe longed for was to be seen as a serious actress; she desperately wanted to be respected. While MMP

negotiated a new deal with Fox, Monroe began acting studies with Lee Strasberg, the artistic director of New York's esteemed Actors Studio. At Strasberg's suggestion, she also began seeing a psychotherapist—as often as five times weekly—to enable her to tap into her thick catalog of charged emotions and memories. Strasberg considered such introspection the fuel of Method acting.

She revered Strasberg, and he, his wife, Paula, and their children would become part of a small group that would wield tremendous influence over Monroe in the last years of her life. She was like another member of the family, often spending nights in the Strasberg home, and she would hire Paula as her drama coach when she returned to filmmaking in 1956. Paula recognized Monroe's fortitude and desire to improve, and she supported Monroe's aspirations. "Marilyn has the fragility of a female but the constitution of an ox," Paula said. "She is a beautiful hummingbird made of iron."

On June 1, 1955, Monroe's 29th birthday, *The Seven Year Itch* opened and became a huge success, which provided her real clout in the ongoing negotiations with Fox. By year's end, she had a new seven-year contract that gave her the power to approve scripts and directors for the films she made at the studio, plus compensation of $100,000 per film. Marilyn Monroe Productions, meantime, would be allowed to make movies independent of Fox. In an article titled "The Winner," *Time* magazine remarked that despite the snickering that had followed her desertion to New York—she was ridiculed in the press for her association with the Actors Studio and lampooned on Broadway in a comedy about a blonde who feels

Marilyn

underappreciated and starts her own production company—Marilyn Monroe "had brought to its knees mighty Twentieth Century-Fox."

In March 1956, she legally changed her name to Marilyn Monroe. This move is interesting because it is clear from the testimony of friends and associates that she was acutely aware that the Marilyn Monroe perceived by the public was in part a creation, a character, even a caricature. A telling anecdote, as recalled by her friend Truman Capote: One day in 1955, the two of them were leaving a restaurant together. Monroe decided to use the powder room. Capote later wrote, "I wished I had a book to read: her visits to powder rooms sometimes lasted as long as an elephant's pregnancy." Eventually he decided to check in on her. Knocking, he opened the door to find her before a mirror. "What are you doing?" he asked.

"Looking at Her," she said.

Other times, she would critique her own scenes with phrases like "No, Monroe wouldn't do this," and friends said that she could turn on the Monroe persona on a whim when she felt like attracting a crowd.

Now she was legally becoming this legendary figure. And it's very evident that she wanted to take firm control of who Marilyn Monroe was; she wanted to reshape Marilyn Monroe. Before returning to Hollywood in 1956 to embark on her next project for Fox, *Bus Stop*, Monroe laid out plans for the movie that would follow, which would be a major production for MMP. For her costar in that film, *The Prince and the Showgirl*, she recruited none other than Sir Laurence Olivier. For an actress to play opposite the great

Olivier, she believed, well then . . . that actress would have to be taken seriously. But even at the New York City news conference announcing Olivier's involvement, she was reminded of how far Marilyn Monroe still had to travel. A reporter asked about her designs to play Grushenka in the *The Brothers Karamazov*, and she was then asked to spell the character's name.

"Look it up," Monroe replied.

She would not have to wait for *The Prince and the Showgirl* to gain a modicum of critical praise. Although she was often anxious and upset on the set of *Bus Stop*—her film comeback, after all, and one in which she would trot out her Method skills for the first time—she turned in a winning performance. "Hold onto your chairs, everybody, and get set for a rattling surprise," read *The New York Times* review. "Marilyn Monroe has finally proved herself an actress in *Bus Stop*."

On top of that, the box office was, again, boffo.

Back in January 1951 in California, Monroe had met and been attracted to Arthur Miller, the playwright who, two years earlier, had won a Pulitzer Prize for *Death of a Salesman*. In 1955, this time on the East Coast, they reunited and began an affair that would doom Miller's marriage. "She was a whirling light to me then," Miller would later write, "all paradox and enticing mystery, street-tough one moment, then lifted by a lyrical and poetic sensitivity that few retain past early adolescence."

After Miller was divorced from his wife, Mary, in 1956, he applied for a passport renewal so that he could travel to London; he planned to be there for a production of one of his plays and to

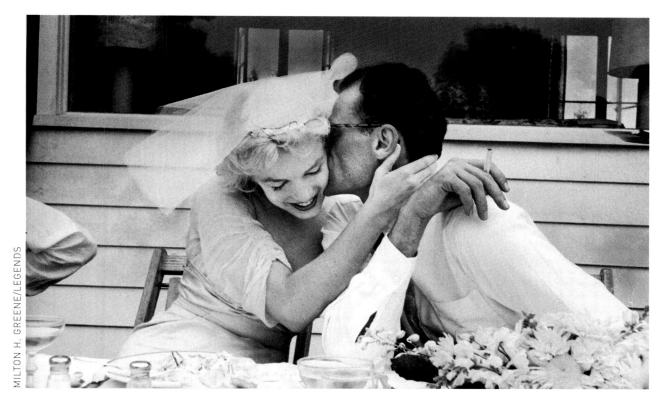

It is early summer in 1956, and America's unlikeliest couple, movie star Marilyn Monroe and playwright Arthur Miller, celebrate their nuptials in Westchester County, New York.

accompany Monroe as she worked on *The Prince and the Showgirl*. But suddenly, he was summoned to testify in Congress before the House Un-American Activities Committee (HUAC), which said it was looking into passport fraud.

For more than a year, Miller had been attracting the scrutiny of the committee, which had, as one focus, the goal of rooting out any Communist infiltration of the entertainment industry. In 1953, Miller's heralded play *The Crucible* had made a metaphorical link between the work of HUAC and the Salem witch hunt trials of America's Colonial era. Whether the play contributed to Miller's being called to Washington has never been proved but always supposed.

Miller, well aware of which way the wind was blowing, told the committee in advance of the passport-fraud hearing that if he were pressed to name names of any associates who might have Communist sympathies, he would refuse to do so. And so he entered the room.

Warned that she was putting her popularity

in jeopardy, Monroe nevertheless was steadfast in her support of Miller. As might have been expected, the committee demanded that Miller tell all that he knew—not about passports but Commies. He responded: "I could not use the name of another person and bring trouble on him." Miller would subsequently be cited and convicted for contempt of Congress, a ruling that would be reversed on appeal in 1958.

But in the midst of the turmoil in Washington, before any citations had been handed down, Miller announced something that was even more consequential than Communists were to a certain sector of America: He said that he planned to marry Marilyn Monroe in a matter of days. It was an unconventional proposal to say the least, but the lady said yes.

They were wed, first in a civil ceremony on June 29, 1956, and then again two days later in a Jewish ceremony before a small group of guests.

A headline in *Variety* captured the prevailing view marvelously: EGGHEAD WEDS HOURGLASS.

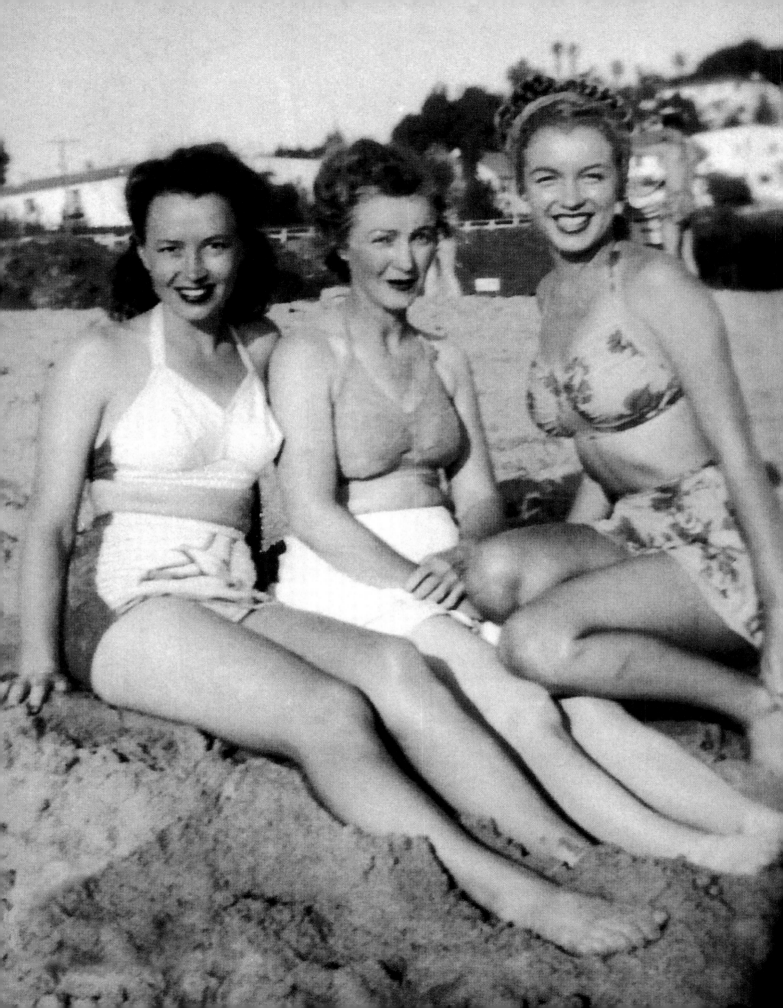

The extraordinary picture opposite, taken on the Santa Monica beach in 1946, shows Berniece Baker Miracle (left), her mother, Gladys Baker, and her half sister, the former Norma Jeane Baker, now calling herself Marilyn Monroe. Berniece and her daughter, Mona Rae, have flown from their home in Florida for a small family reunion as Gladys has recently been released from the state hospital after a nine-year stay (she would, as we know, continue to be in and out of institutions for the rest of her life). Berniece would reminisce about that visit in a 1994 article in LIFE that corresponded with the publication of her memoir, My Sister Marilyn, *co-written with her daughter. She said that their mother rarely smiled and had become obsessed with Christian Science since her breakdown. She said that, at the time, Marilyn was also practicing Christian Science and reading the Bible every night. Marilyn at one point sneaked Berniece onto the Twentieth Century-Fox lot, arranged a viewing of her recent successful screen test and took her to the commissary. The sisters were rarely together after the three-month California visit but continued to correspond by mail, and Berniece remembered theirs as a loving relationship. One of Marilyn's letters had particularly poignant passages that captured the heartbreak of this ruptured family: "By the way, do you remember Mother at all? . . . She and I can't seem to be very close due to no one's fault." When Marilyn Monroe died, Berniece flew West once more to help Joe DiMaggio pick out a casket. Above: The young actress in Los Angeles in 1947.*

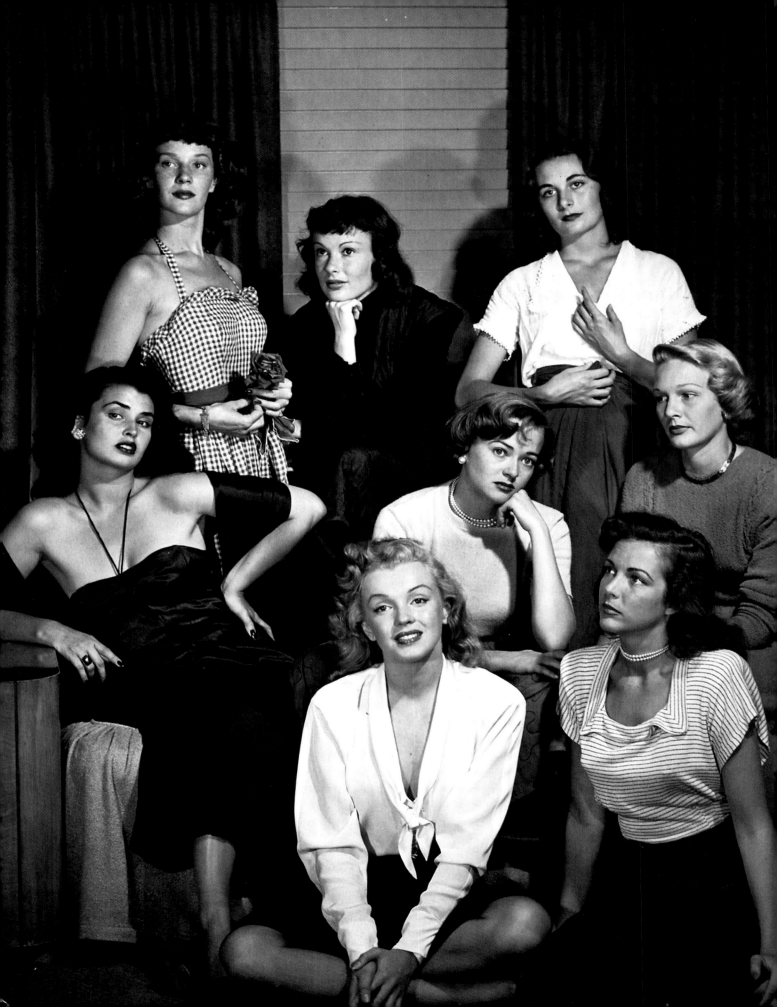

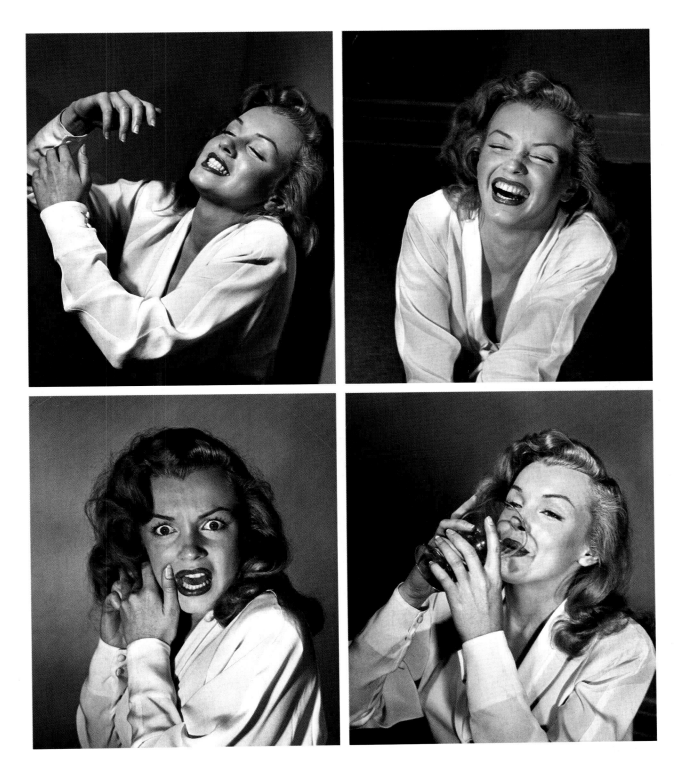

The title of the article was "Eight Girls Try Out Mixed Emotions," and the subtitle read: "A LIFE photographer conducts an experiment to see if movie starlets' acting is as good as their looks." The scenes that Philippe Halsman asked the starlets to act out included (as executed by Monroe, clockwise from top left) embracing a lover, hearing a joke, taking a drink and seeing a monster. Whether or not she won the contest, she certainly won the race to stardom. Monroe is seen opposite in front of Jane Nigh and surrounded by, clockwise from her right, Laurette Luez, Lois Maxwell, Suzanne Dalbert, Ricky Soma, Dolores Gardner and Cathy Downs. Although Downs had a lead role in the John Ford classic My Darling Clementine, it was probably Maxwell who finished second best in the fame game: She was Miss Moneypenny in many of the best-known James Bond films.

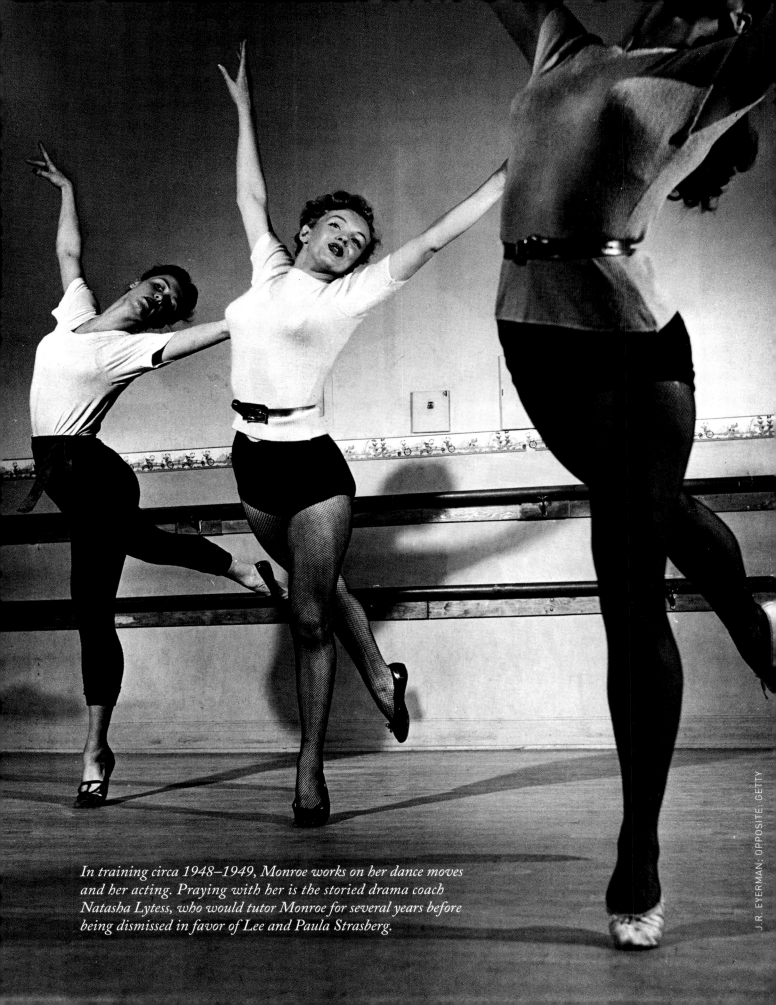

In training circa 1948–1949, Monroe works on her dance moves and her acting. Praying with her is the storied drama coach Natasha Lytess, who would tutor Monroe for several years before being dismissed in favor of Lee and Paula Strasberg.

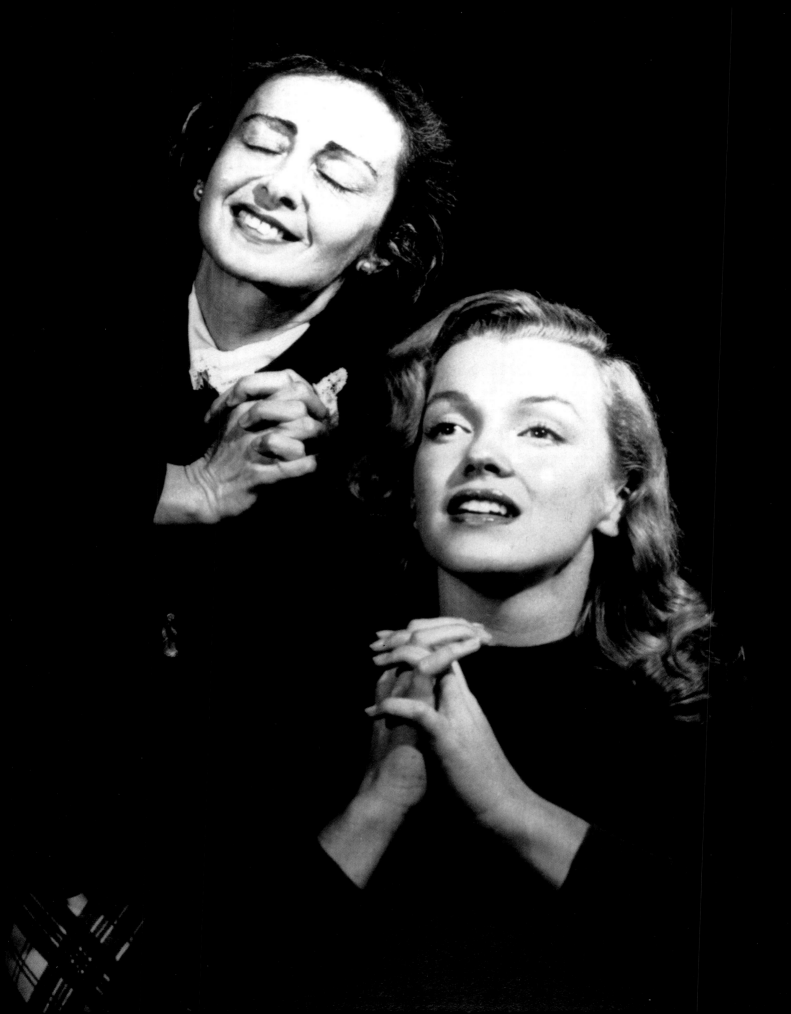

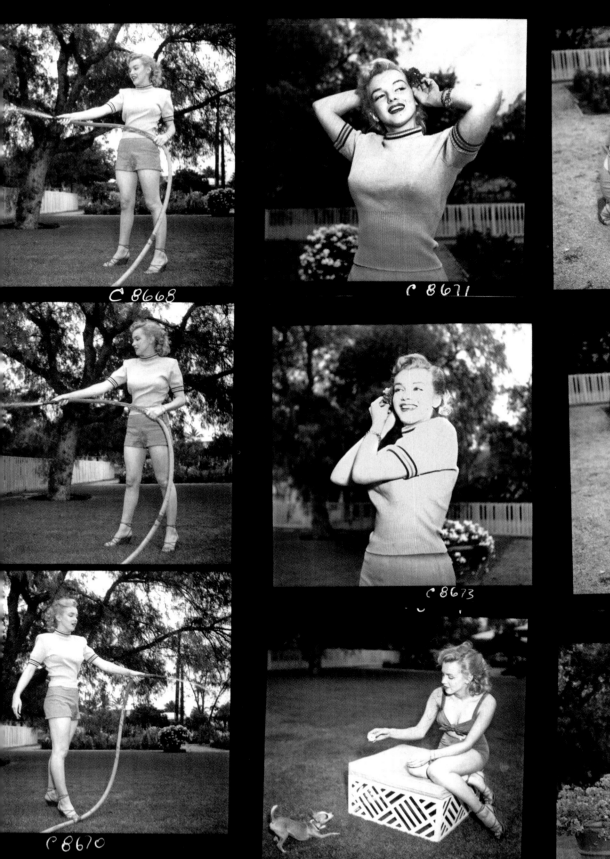

C 8668

C 8671

C 8670

C 8673

C 8750

C 8677

C 8678

C 8675

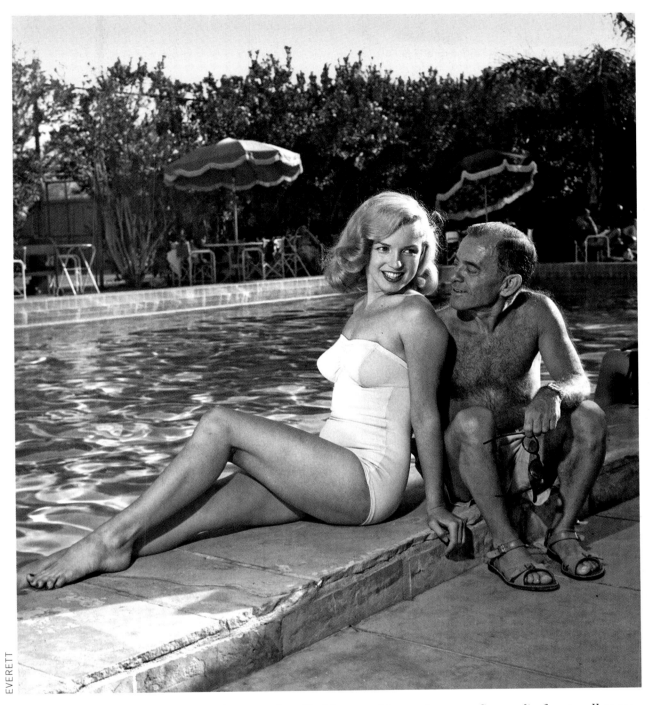

The man pictured poolside with Monroe is described by some biographers as a Svengali of sorts; all agree that he was instrumental in the early chapters of the actress's career. His name was Johnny Hyde, and he was a powerful Hollywood talent agent. By the time he began working with Monroe, she had already lost her first studio contract and was foundering in her quest for stardom. Hyde suggested some plastic surgery on her chin and urged her to bleach her hair platinum on regular occasion. He then used his great influence to get her important roles in The Asphalt Jungle *and* All About Eve *and helped secure a second contract with Fox—critical deals that would position her for all the success that followed. While it has been written that Hyde, a married man then in his fifties, was in love with Monroe and tried to woo her, she herself asserted that there was no affair. The photo above and those on the contact sheet on the opposite page were taken on May 17, 1950, in the backyard of Hyde's home at 718 North Palm Drive in Beverly Hills, where the agent made a series of photos that would be used in spreading the word about Monroe.*

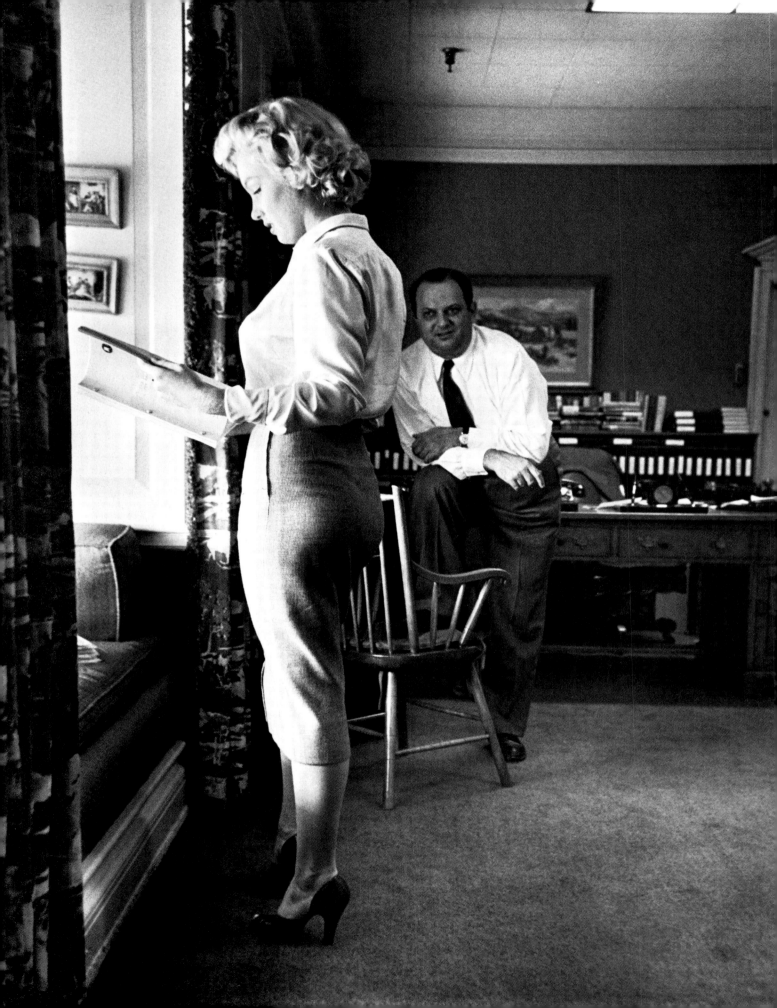

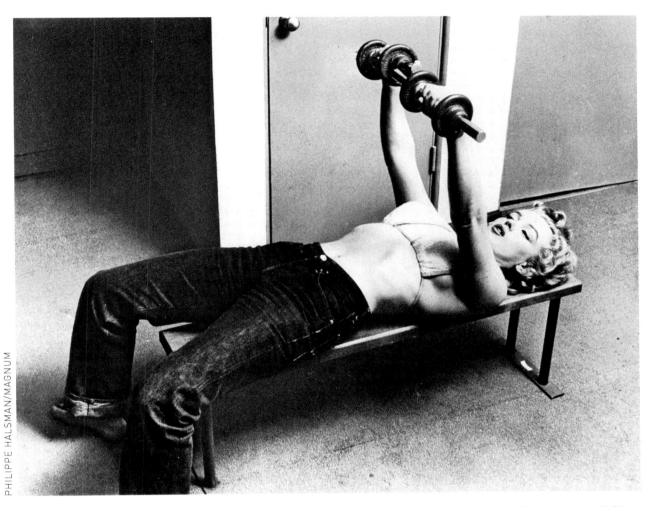

The two sometimes warring sides of Monroe the actress: the cerebral and the physical. Opposite, in 1951, she reviews a script adapted from the Clifford Odets play Clash by Night, *and then, above, in 1952, she works on her increasingly famous physique. Interviewing Monroe in his office is* Clash by Night *producer Jerry Wald, and this is just the kind of production she hopes to join. A slew of "serious" names are already attached to the project: Not only did the esteemed Odets write the original story (which was directed on Broadway in 1941 by Lee Strasberg), but Fritz Lang is slated to direct the film, and Barbara Stanwyck and Robert Ryan are set to star. Monroe does win a secondary role, and although the final product hardly represents top-shelf Lang, her appearance in the film amounts to a positive career move.*

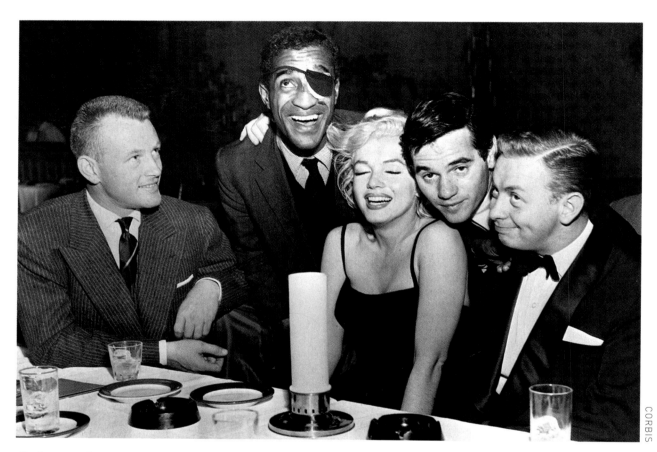

<div style="text-align: right">CORBIS</div>

Only yesterday she was one of a thousand anonymous starlets, and the day before that she was a nobody. Now, however, Monroe finds that she has joined the club. Opposite: She awaits her cue to take the stage and present an Oscar at the 1951 Academy Awards. Above: On a night out at the swank Crescendo nightclub on the Sunset Strip, Monroe is visited by fellow celebrities Sammy Davis Jr. (with the eye patch) and the club's headliner, Mel Torme (far right). Monroe's escort on this night is the noted celebrity and fashion photographer Milton Greene, who is at her left shoulder. He met Monroe not long before while doing an assignment for Look *magazine, and they quickly became intimate friends; Monroe would live for a time in the early 1950s with Greene and his family at their Connecticut farmhouse.*

On the pages immediately following: Monroe's status on the A-list would be cemented by her defining performance as Lorelei Lee in 1953's Gentlemen Prefer Blondes, *which costarred Jane Russell, seen here applying a touch-up.*

<div style="text-align: right">GEORGE ZENO COLLECTION</div>

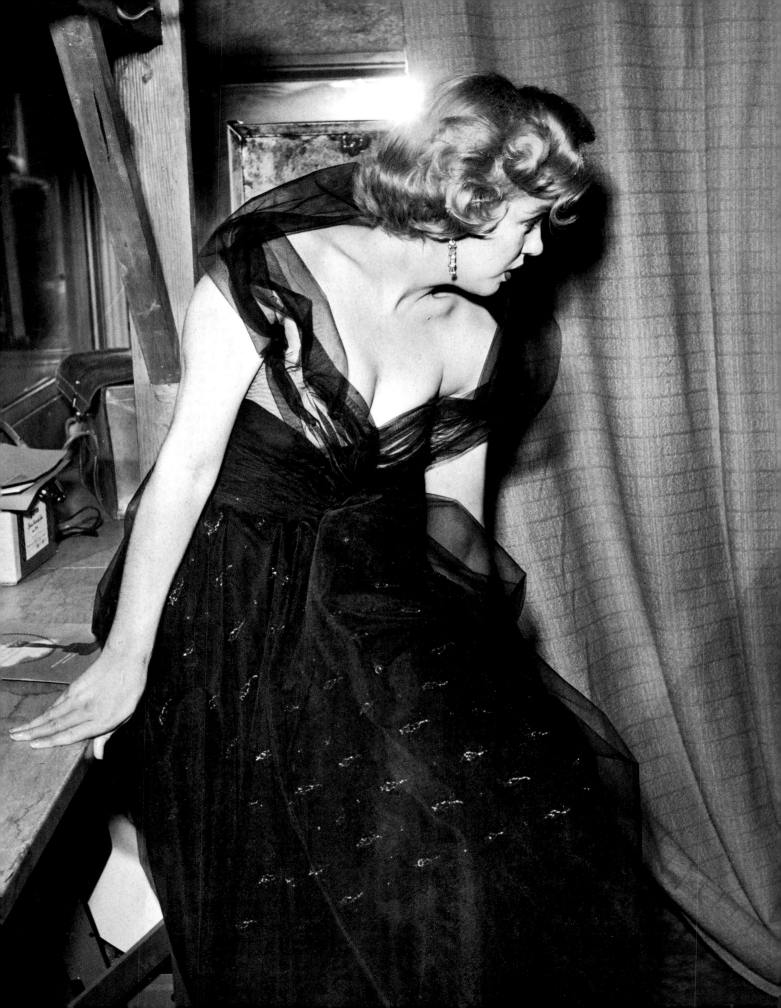

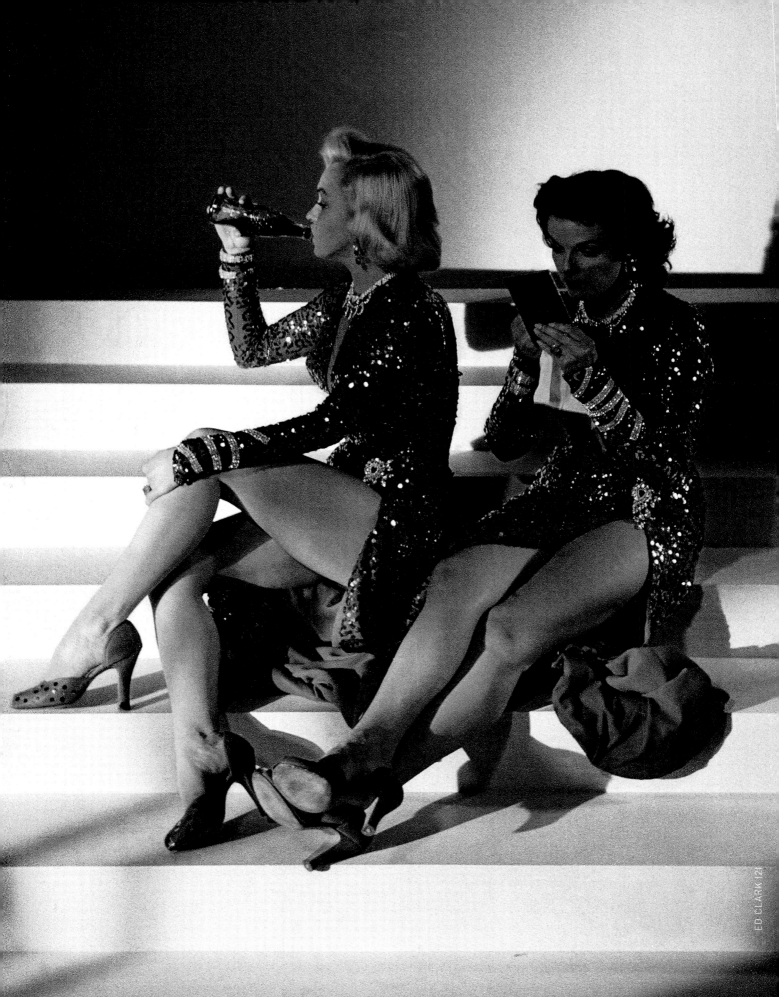

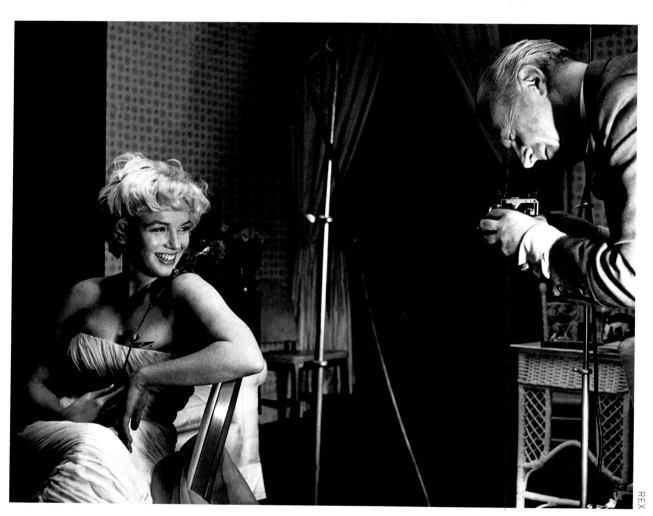

As was mentioned earlier in our book, Monroe, whether she was a great movie actress or not, was an incomparable star of the still image—a fact that we celebrate on these and the next eight pages in pictures made by some of her favorite photographers. She is working here in 1957 with Cecil Beaton, who was kept waiting by the chronically late Monroe but nonetheless enjoyed the collaboration immensely. He later wrote that she was like no one else when acting for the camera: "She romps, she squeals with delight, she leaps on the sofa. She puts a flower stem in her mouth, puffing on a daisy as though it were a cigarette. It is an artless, impromptu, high-spirited, infectiously gay performance. It will probably end in tears."

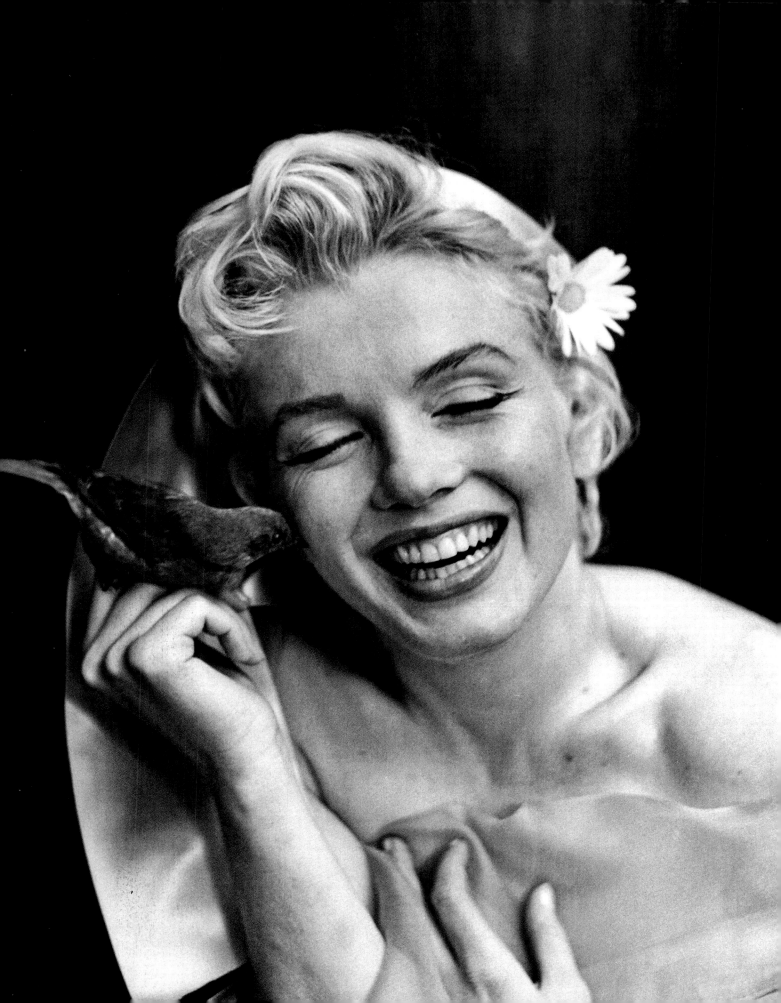

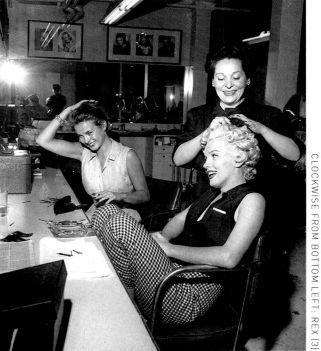
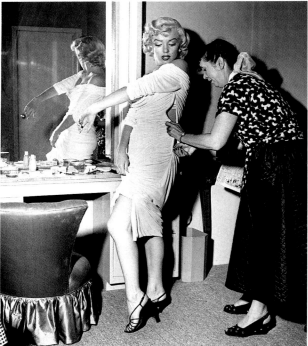
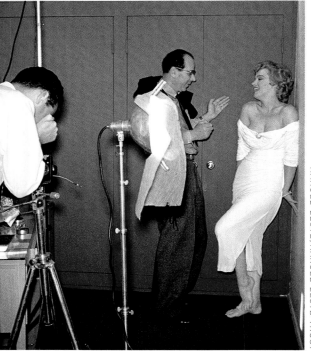

She had been photographed many, many times before the 1952 session in L.A. with Philippe Halsman, but no session had been so important, for this one would yield her first LIFE cover (please see page 46; a fine alternate shot is opposite). "Of the beautiful women I have photographed, I recall Marilyn Monroe most vividly," said Halsman, who is seen conferring with Monroe in the lower right-hand photograph, after she has dressed and been made up. "Her great talent was an ability to convey her 'availability.' I remember there were three men in the room . . . Each of us had the thought that if the others would only leave the room that something would happen between Marilyn and himself." To get a later LIFE cover shot, which can be seen on the back cover of our book, Halsman needed Monroe to jump 200 times. Before she left, she told him to call if another take was necessary—"even if it is four in the morning."

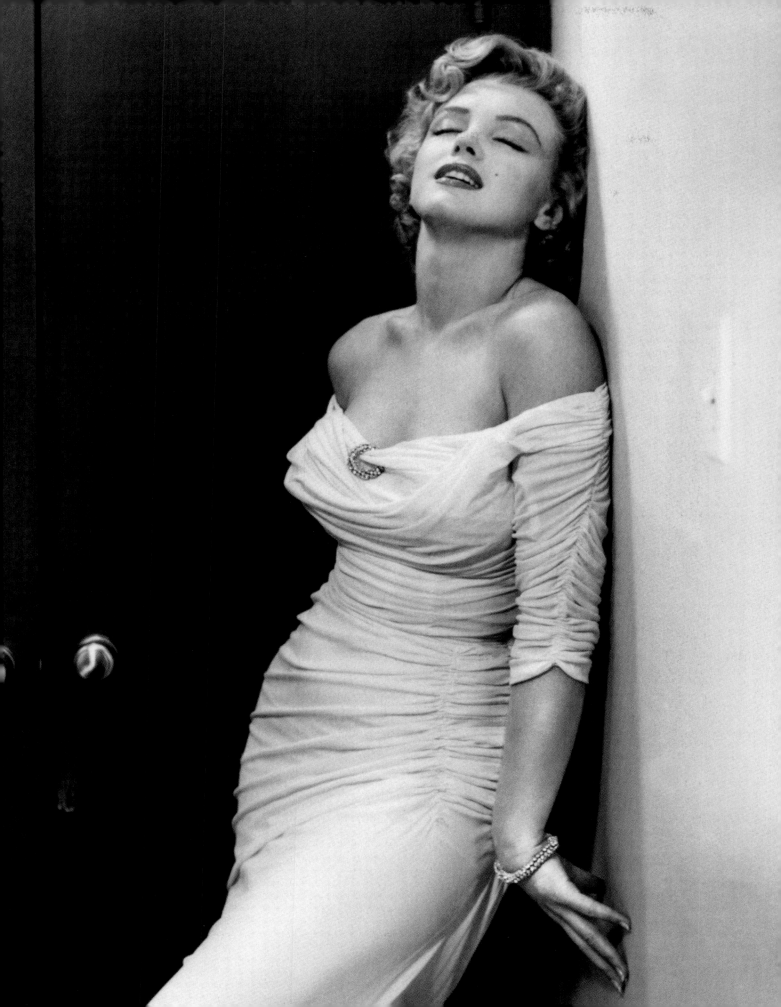

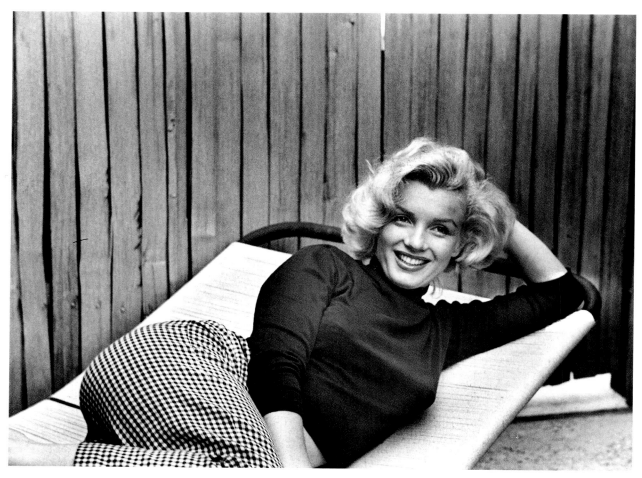

When Alfred Eisenstaedt, one of LIFE's original four staff photographers in 1936, died at age 96 in 1995, his obituary in The Independent of London read in part: "To T.S. Eliot, posing for him in the Fifties, Eisenstaedt seemed like an acrobat. Marilyn Monroe was perplexed by the speed of his portrait sessions, while President Jack Kennedy was amazed that he made it all look 'so easy.' Starting out as an amateur in Twenties Berlin, he became LIFE magazine's top photoreporter. Photojournalist to the famous, he created, in a deceptively offhand style, casual celebrities, a glitterati made accessible across America." Just so, and during a private (and apparently fast-paced) 1953 session at her home that had been arranged by a mutual friend, Monroe showed a very human face to the country. "When I photographed Marilyn Monroe, I mixed up my cameras," Eisie later recalled. "One had black-and-white film, the other color. I took many pictures. Only two color ones came out all right. My favorite picture of Marilyn hangs always on the wall in my office. It was taken on the little patio of her Hollywood house." That patio is the setting for the picture above and the one on the front cover of this book; the photograph opposite is another color shot that worked.

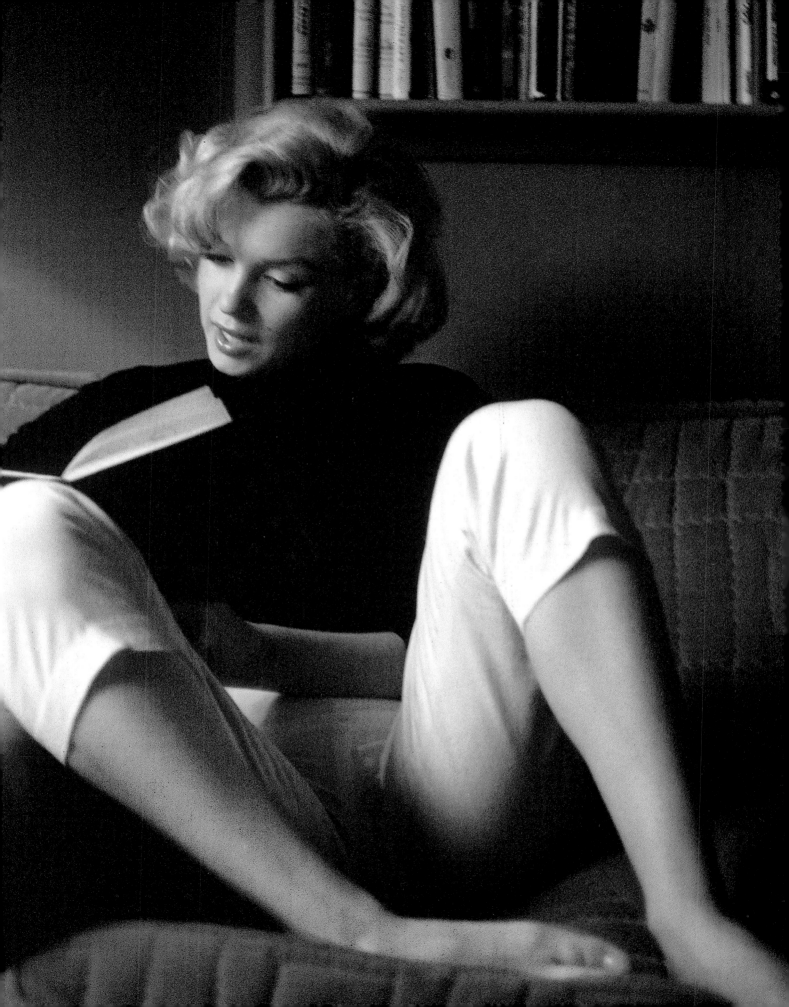

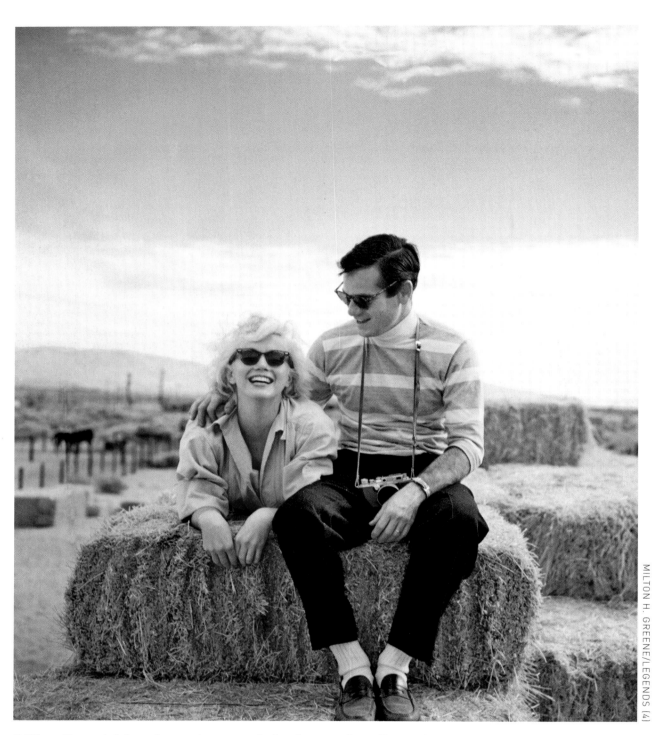

MILTON H. GREENE/LEGENDS (4)

Milton Greene's job, as he saw it, was to be "a photographer of beautiful women." Greene worked in the fashion industry before joining LIFE and developed a reputation for theatrical photo shoots. His stylist once recalled, "The way Milton would work, he would bring in the props, turn on the music—it was Stravinsky for Marlene [Dietrich]—turn off the phones and bring out the sherry." Greene photographed nearly everyone who was glamorous or fabulous in the mid–20th century—including men from Cary Grant to Norman Mailer—but he is best remembered for his extensive work with his dear friend Monroe (seen with him, above, in 1954). Over four years in the mid-1950s, he photographed her during 52 sessions, including the famous "Ballerina" pictures of 1954 (opposite) and the "Black Sitting" in 1956. Not only did he help her form her film production company, he also collaborated with her on her memoir, My Story, *and later worked with Mailer on a fictional autobiography of Monroe,* Of Women and Their Elegance.

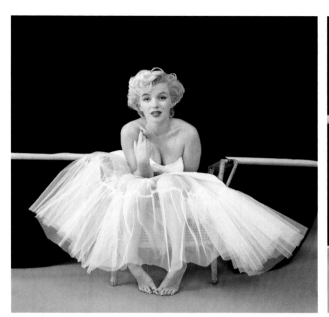

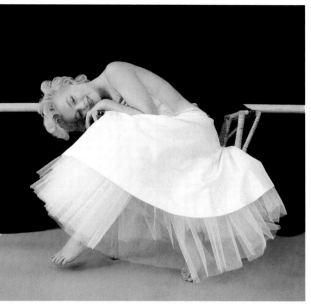

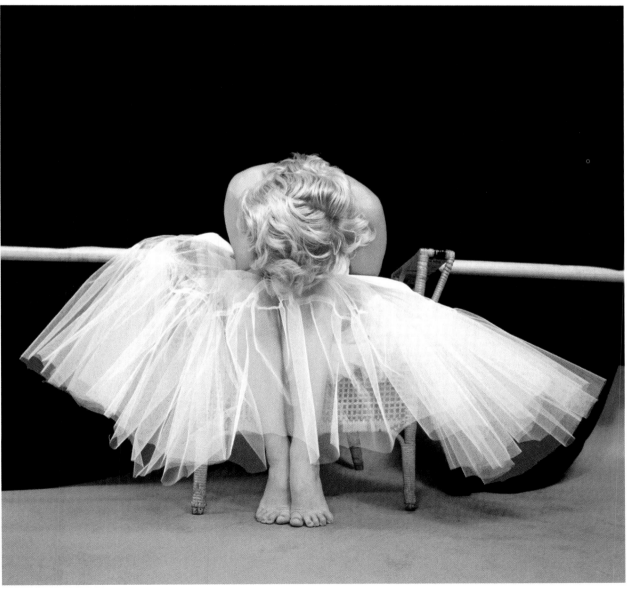

Most of LIFE's photographers had a knack for capturing the essence of people, for laying claim to their most characteristic moments. Ed Clark had this ability in spades, as we saw shortly before in his candid photograph of Monroe and Jane Russell on the set of Gentleman Prefer Blondes *(page 66).* Clark was onto Monroe even earlier, in 1950, when he was told by a friend at Twentieth Century-Fox that the studio had signed "a hot tomato." Clark later recalled to the Sarasota Herald-Tribune: *"She was unknown then, so I was able to spend a lot of time shooting her. We'd go out to Griffith Park, and she'd read poetry. I sent several rolls to LIFE in New York, but they wired back, 'Who the hell is Marilyn Monroe?'"* They would soon learn, and as we have seen, it would fall to Philippe Halsman to produce her first cover image for the magazine in 1952. But before the glam shots by Halsman and Beaton, there were Clark's fresh and somehow innocent pictures from Griffith Park (one of which is seen above); they were never published and seem revelatory today. Opposite: A Clark portrait also made in 1950.

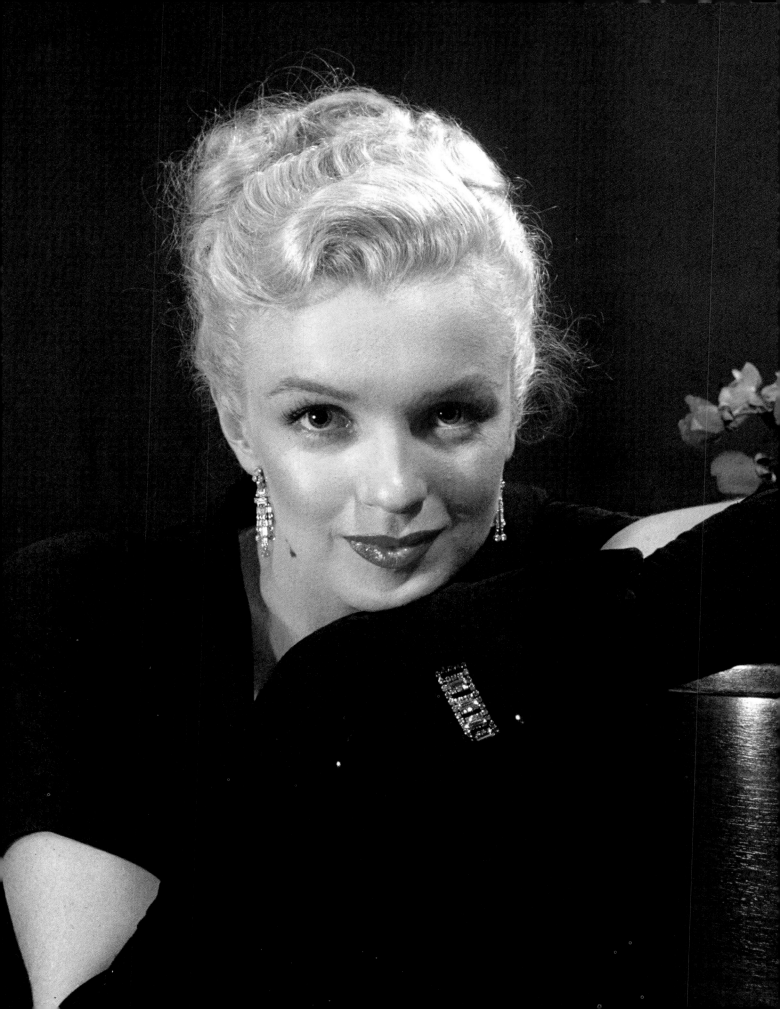

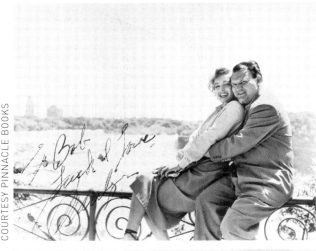

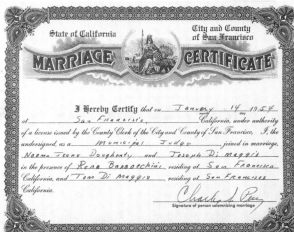

Was Monroe very briefly married to writer Bob Slatzer, seen with her at top during the filming of Niagara, in 1952? It is one of the lingering mysteries of her minutely scrutinized life. But she was definitely wed to baseball legend Joe DiMaggio on January 14, 1954, in the City by the Bay—and there's paper to prove it (above). At right, Monroe and Joltin' Joe hold hands as they depart City Hall after the wedding ceremony. She is clearly elated, while he seems already upset by the fuss. Though their official union would be brief, he would remain a part of her life—and would in fact make a late return as a key player—until her death.

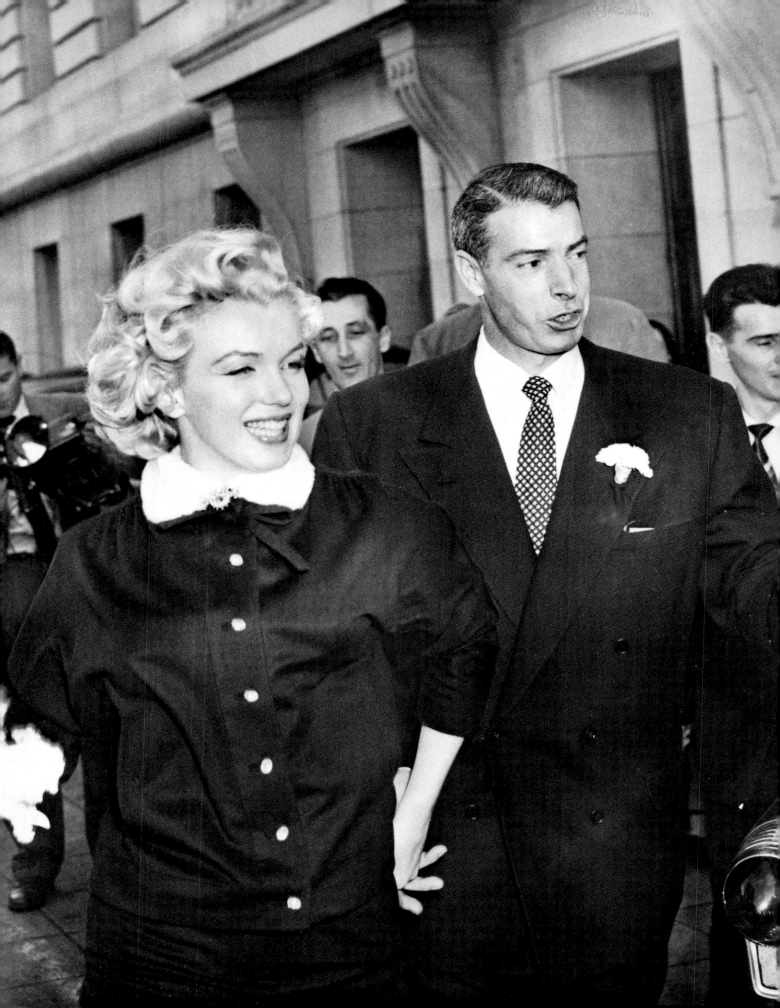

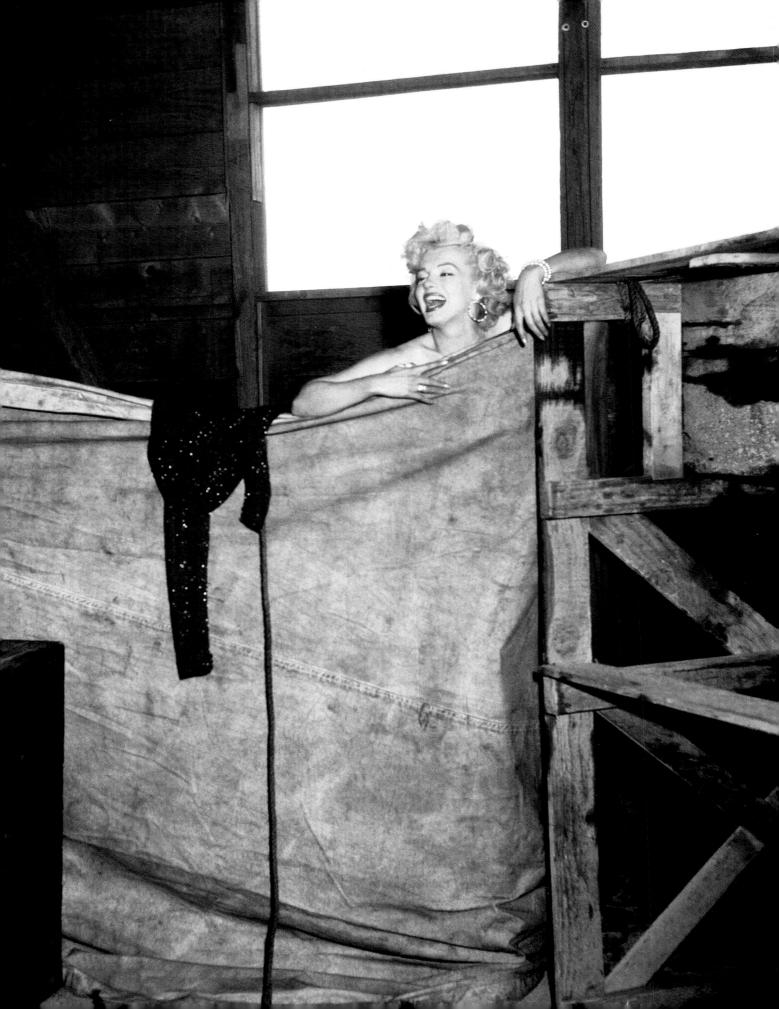

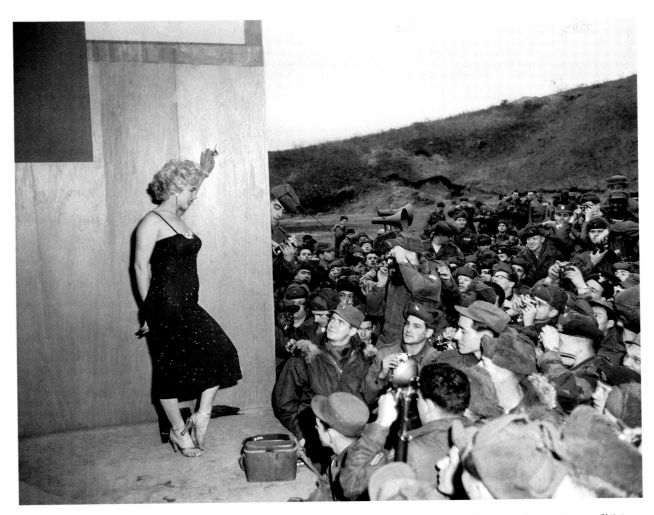

DiMaggio had already been slated to do a baseball-related promotional tour of Japan that winter of '54, and when an unsettling furor attended his marriage in the U.S., he decided to turn the trip into a honeymoon: In a foreign land, certainly, they would enjoy some peace, right? Fat chance. The crush in Japan was constant and cacophonous. Then Monroe was off to South Korea to entertain the troops. For four days, she toured military bases wearing only a tight purple dress in below-freezing temperatures (opposite, changing into the dress in a makeshift dressing room at the K-47 air base in Chunchon). None of the 100,000 servicemen who saw her went away disappointed, although the show was admittedly light on formal entertainment. When DiMaggio first heard that they wanted Monroe in Korea, he said the idea was absurd because "she doesn't have an act." But as Monroe proved, she didn't need one. She sang a few songs ("Diamonds Are a Girl's Best Friend," of course, and one called "Do It Again" that had to be changed to "Kiss Me Again" after a riot broke out at one of the bases), posed for a few photographs (above) and took a few questions (on the pages immediately following; one query apparently concerned her toenail polish). That was more than enough to keep the guys happy—and one guy, her new husband, profoundly annoyed.

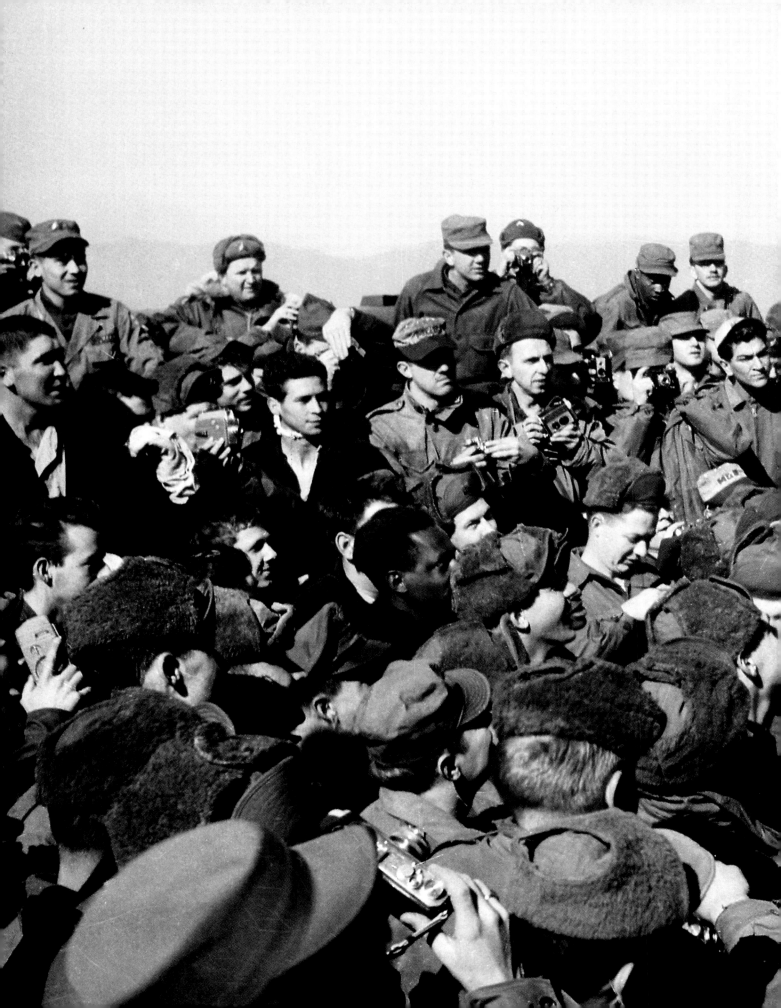

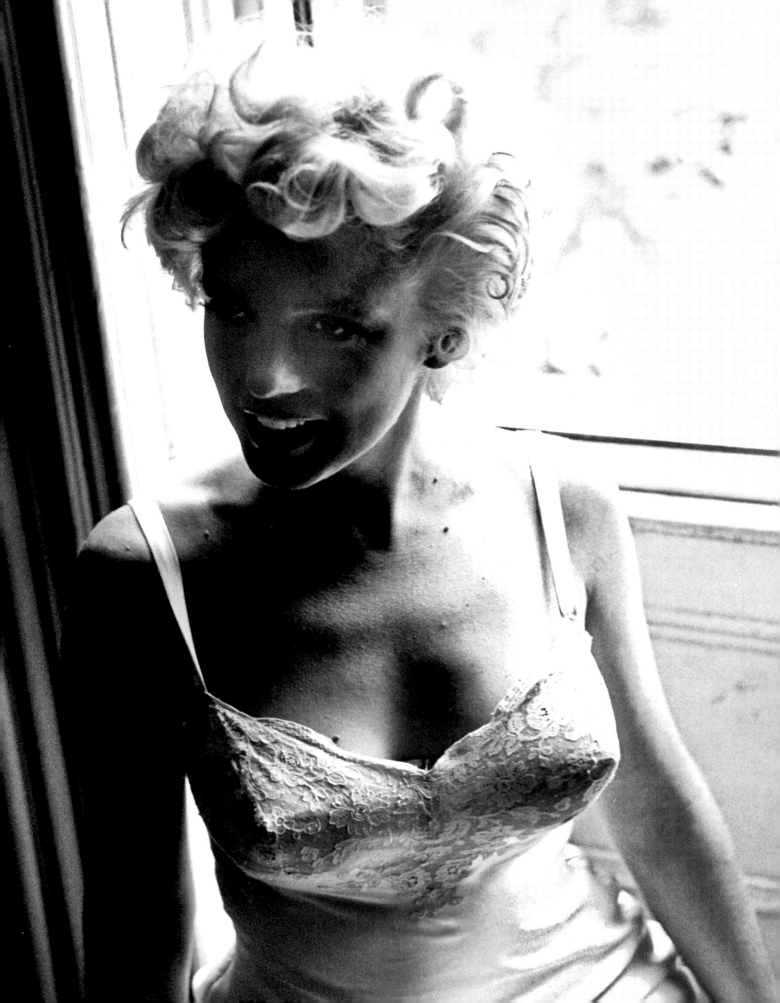

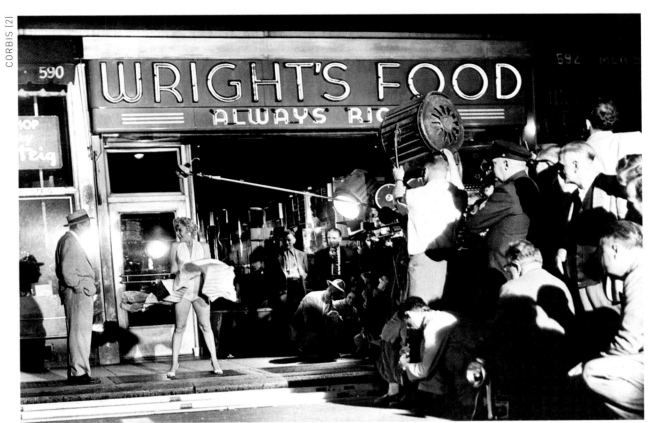

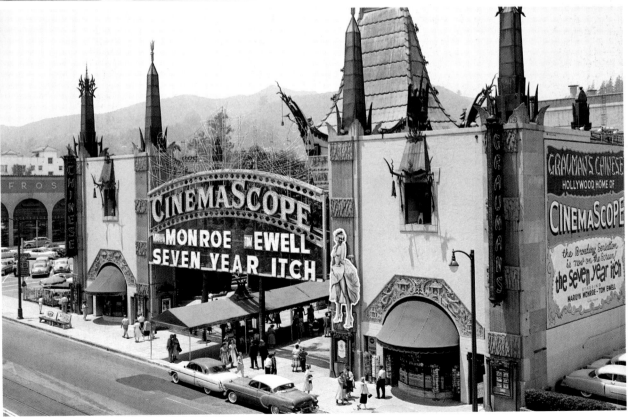

The triumph and the tragedy: In 1954, Monroe plays va–va–va–voom in New York City for photographers and fans during the filming of The Seven Year Itch *(opposite and top), helping turn the film into a huge hit (above, the premiere in Hollywood). But the behavior also helps doom her marriage.*

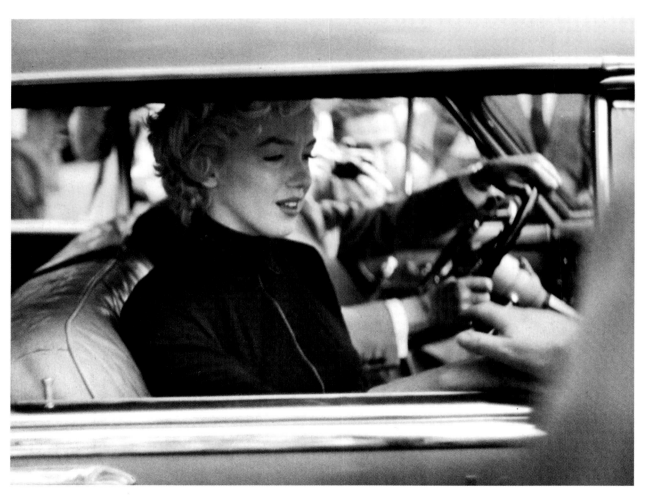

Monroe and DiMaggio were not allowed to wed, honeymoon or live in peace, and they certainly would not be allowed to divorce in peace. Once back in L.A., Monroe told The Seven Year Itch *director Billy Wilder and Fox PR man Harry Brand that the marriage was finished and would soon be officially so. Knowing there was no way to hold back a flood of rumor and speculation, Brand proactively released this news to reporters. Instantly, the Beverly Hills home where Monroe and DiMaggio lived was a fortress under siege. For two days, Monroe remained holed up inside, and the studio announced there would be a news conference on October 6, 1954. When she emerged that day, reporters and photographers lunged forward, screaming questions and snapping shutters as Hollywood lawyer Jerry Giesler escorted her to a waiting car. A reporter who was there and part of the scene, Joe Hyams of the* New York Herald Tribune, *years later remembered the shame he had felt. He recalled "as clearly as I had seen it then, her tearstained face as she came out of the front door, the half-a-hundred newsmen crowded in on her like animals at the kill. Only little Sidney Skolsky tried to protect her. Something about the scene and my profession of journalism sickened me."*

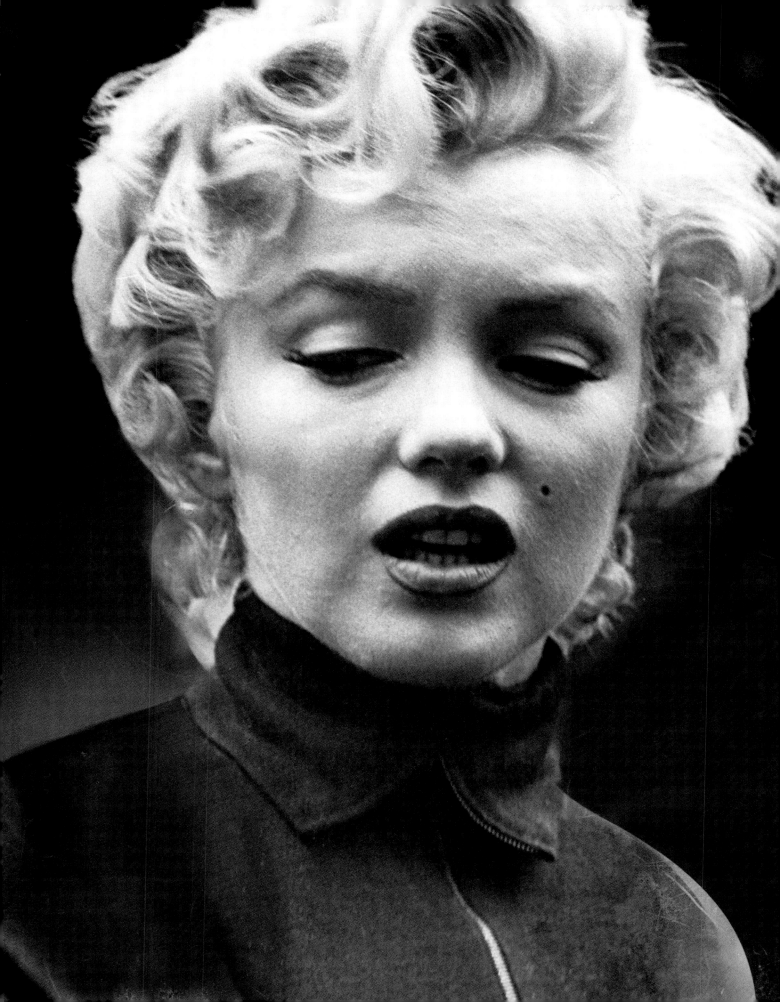

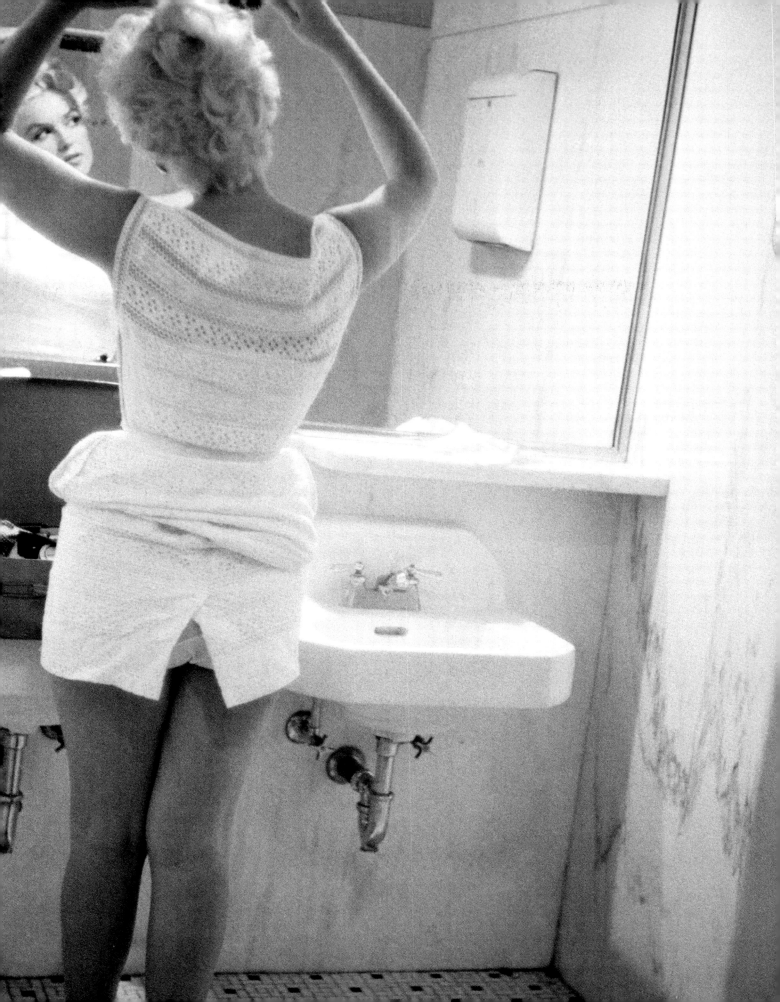

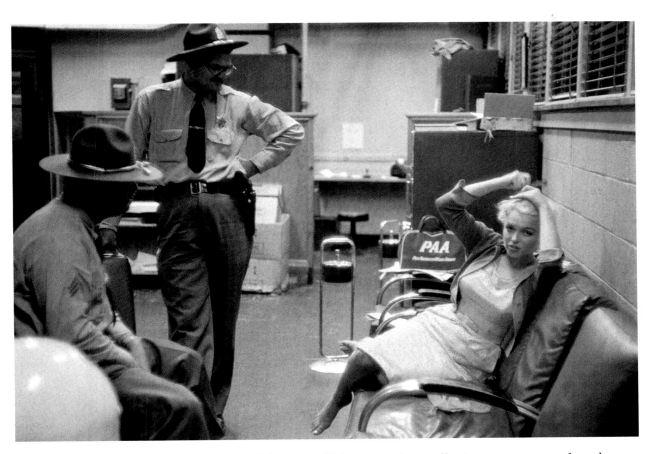

Eve Arnold, the first woman member of the storied Magnum *photo collective, was yet another photographer whose work with Monroe was a career highlight. Arnold is best remembered for her remarkable, very human pictures from the set of Monroe's last completed film,* The Misfits *(which we will sample elsewhere in this book), but in fact she met and first photographed Monroe in 1951. "We were both at the beginning of our careers, and I believe that neither of us knew precisely what we were doing," Arnold once said, adding that she and Monroe were acutely aware that as women in that sexist era, they were often perceived as outsiders or objects: "We could make use of it, or we could let it be." As these comments indicate, she had great empathy for Monroe, even felt a kinship with her. Every frame she made of the film star reflects this. Monroe the person shines through; the sex bomb or screen siren is absent. In the photographs on these and the next four pages, Arnold documents in warm, lovely pictures a rather banal movie-star assignment: a trip to Bement, Illinois, in 1955 to be the requisite celebrity at the town's centenary celebration. (Above: Bement's finest greeting Hollywood's. Opposite: Before her flight from Chicago to Champaign, a touch-up; the flight is seen on the next four pages.) As these photographs and those from* The Misfits *clearly imply, Monroe trusted Arnold as she did no other photographer.*

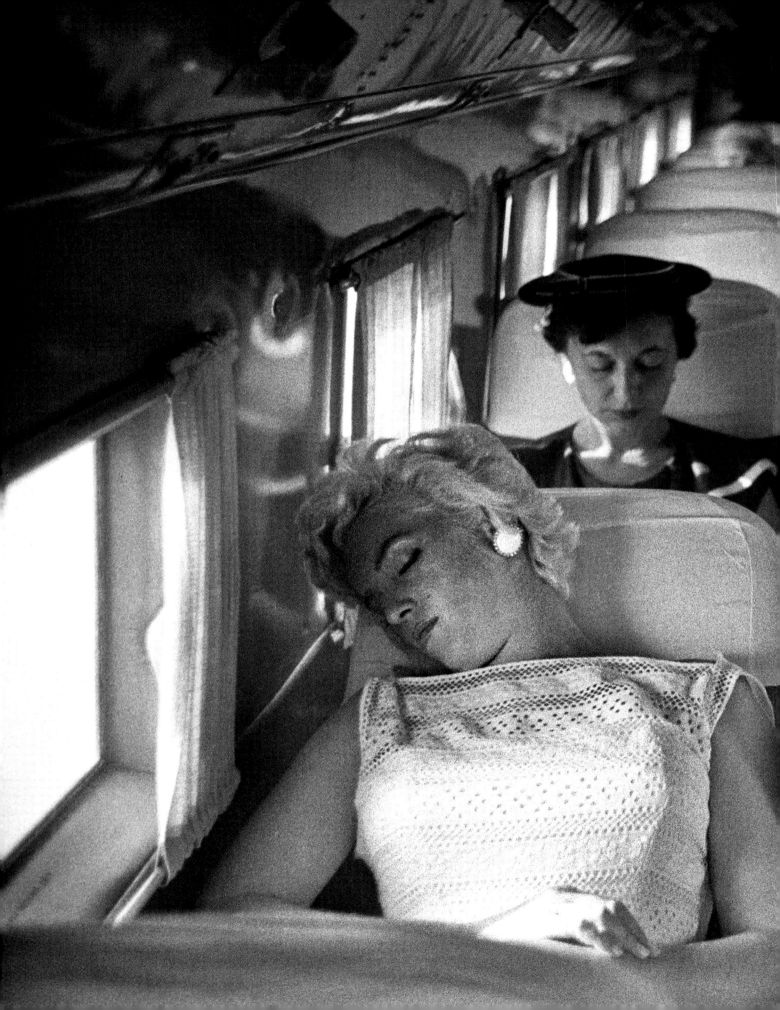

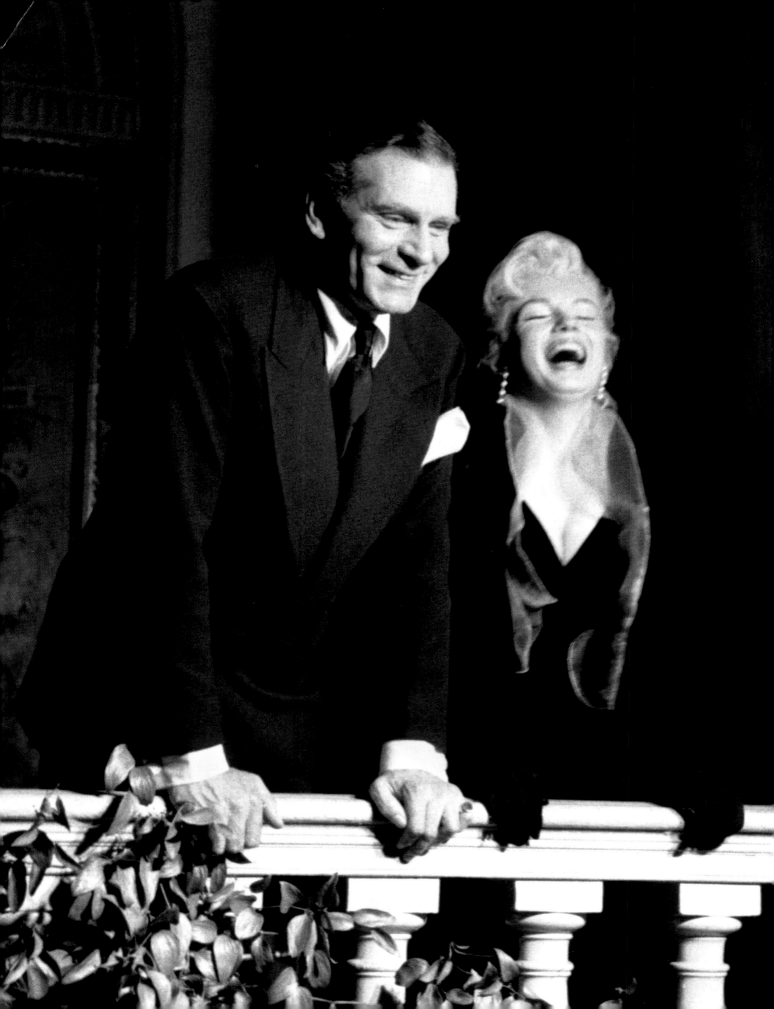

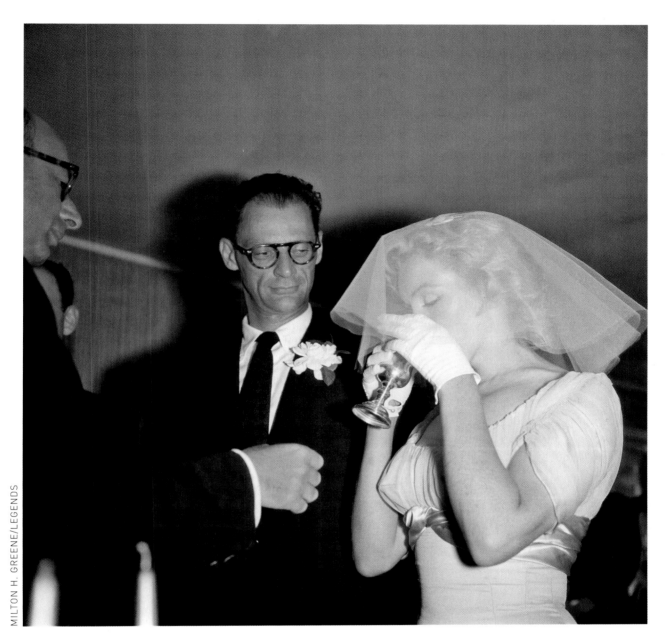

Monroe's meeting of the minds: In 1956, Monroe is linked with two heavyweight intellectuals, Laurence Olivier (opposite) and Arthur Miller (above). The event with Olivier is a press conference at New York City's Waldorf-Astoria Hotel to announce that Marilyn Monroe Productions has secured the services of Olivier as director and costar of The Prince and the Showgirl. *Monroe, who is peppered with snarky questions, fully realizes what is at play: "Some people have been unkind. If I say I want to grow as an actress, they look at my figure. If I say I want to develop, to learn my craft, they laugh. Somehow they don't expect me to be serious about my work. I'm more serious about that than anything. But people persist in thinking I've pretensions of turning into a Bernhardt or a Duse—that I want to play Lady Macbeth. And what they'll say when I work with Sir Laurence, I don't know." What they'll say when they learn in June that Monroe has actually wed Miller is something along the lines of* Ya gotta be kiddin' me!? *But both the civil and religious ceremonies are real enough, and there are pictures to prove it, as we see above and on the pages immediately following.*

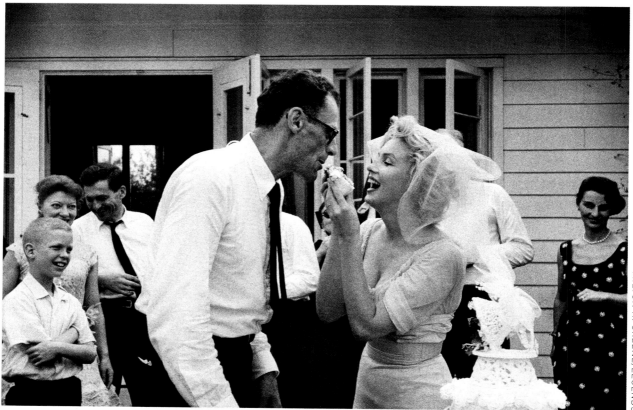

MILTON H. GREENE/LEGENDS

Monroe and Miller were wed in a civil ceremony on June 29, 1956. But the pictures on the previous two pages and immediately above are from a second fete, two days later, at the home of Miller's literary agent, Kay Brown, in Westchester County, New York. Some 30 friends and relatives attend the hastily arranged party. Everything is moving so fast that even for this confirming wedding, Miller has to borrow his mother's ring for Monroe's finger. In rural Roxbury, Connecticut (opposite and on the pages immediately following), where Miller has owned property for a decade, the newlyweds can escape from Manhattan. Miller's first abode in Roxbury, basically a shack, is woefully insufficient for the two of them, and in 1958, they buy a four-bedroom clapboard farmhouse just down Tophet Road. Three hundred and fifty idyllic acres of land surround their home, which was originally built in 1769. As the joy on Monroe's face indicates, this was a time of great hope and optimism. Miller, for his part, never left Roxbury. In 2005, he was 89 years old and receiving hospice care at his sister's Manhattan apartment when he realized that the end was near. He asked for an ambulance to bring him to Roxbury, where he died on February 10, gazing out at paradise.

GLOBE

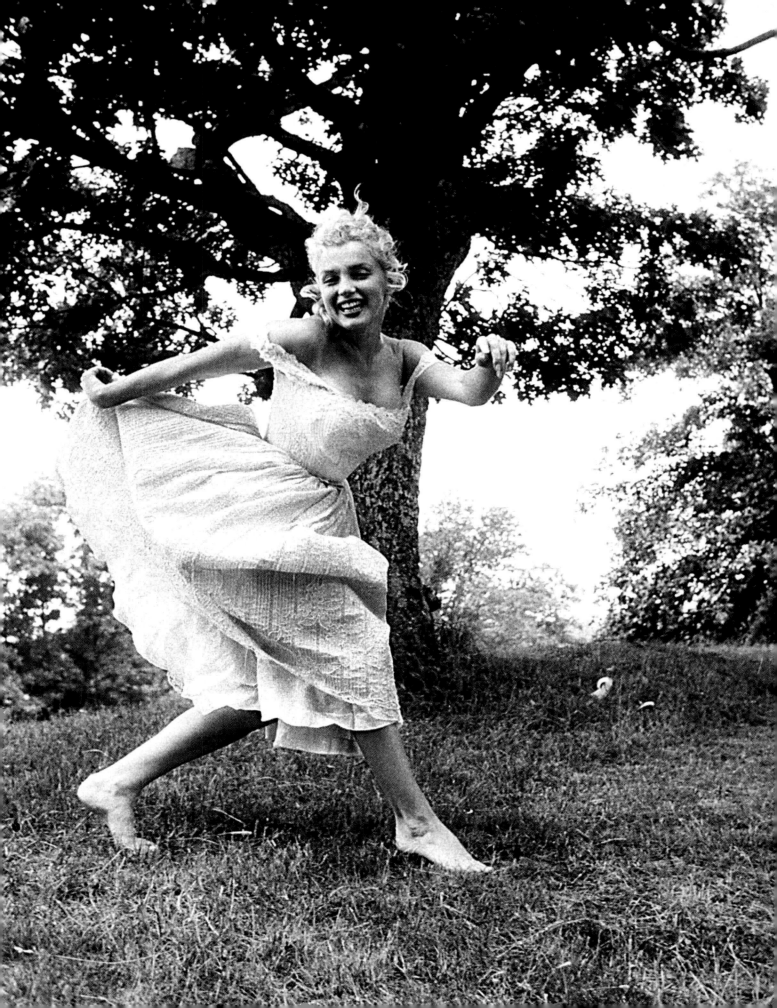

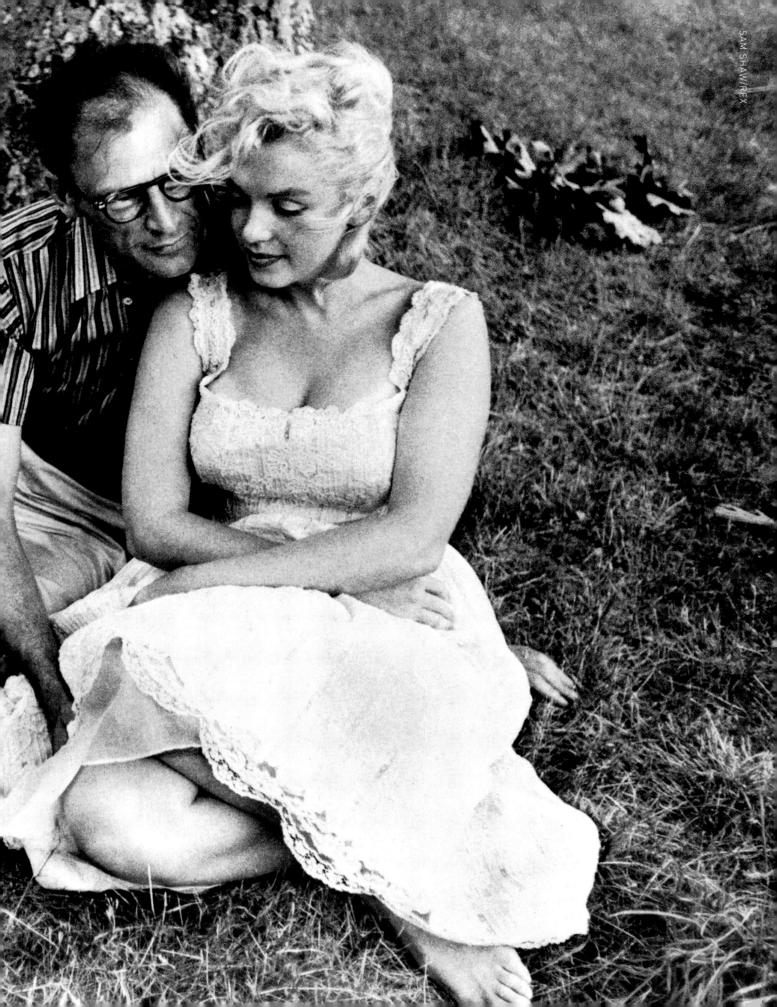

The Fall

"A brilliant comedienne" was Laurence Olivier's assessment of his costar Marilyn Monroe before they began filming *The Prince and the Showgirl* in London in 1956. "And therefore an extremely good actress," he added. A few weeks into production

Olivier, who directed as well as acted in the movie, may have been somewhat less gracious with his words.

Not that Monroe showed any glaring lack of talent, but her behavior—and especially the conduct of her entourage—made for a tense, unhappy set. Beginning with *Bus Stop,* Monroe had replaced drama coach Natasha Lytess with Paula Strasberg, and the new tutor's ubiquity would factor into all Monroe's final movies, much to the dismay of a string of directors. Olivier considered Strasberg a sycophant, a buttinsky and even a no-talent phony. There was also resentment that because Monroe was convinced her success hinged on the Method, Lee Strasberg had successfully demanded for his wife an astronomical pay increase to work on the film. So she was in the way, as Olivier saw it, and being royally rewarded for it.

Monroe, for her part, was plunging further into a dependence on pills for sleep and then, in turn, for alertness during the day. Various ailments caused weight fluctuations, which necessitated costume alterations. At one point, according to some accounts, Monroe suffered a miscarriage.

Which brings us to Arthur Miller. He was in London, too, and when visiting the set behaved, according to some who were there, in a highly arrogant manner. He seemed to display little respect for his wife.

Such observations were probably spot-on, for it seems the bloom went off the rose of this relationship as quickly as it had in Monroe's earlier marriages. Monroe was understandably hurt when she happened upon an entry in the playwright's open notebook that implied he was disappointed in her, that she wasn't the "angel" he had initially thought her to be.

But amid all this rancor and recrimination, Monroe turned in a performance the gallant Larry Olivier called "quite wonderful." In Italy, she won that country's version of the Academy Award; in Britain, she was nominated for its equivalent; and in France, she won the Crystal Star. A corner was being turned in the way the film world regarded Marilyn Monroe, which is poignant to consider: Even as she was gaining what she had long sought, and what had looked to her as the ultimate redemption—as the making of her—she was getting caught in a downward spiral from which she would never escape.

After filming wrapped and Monroe returned to New York in late 1956, she started to cut some long-standing ties and forge new ones. She and longtime friend and former lover Milton Greene

She is not acting here; she did smoke. But the hazards of this particular addiction had nothing to do with her tragic, untimely death.

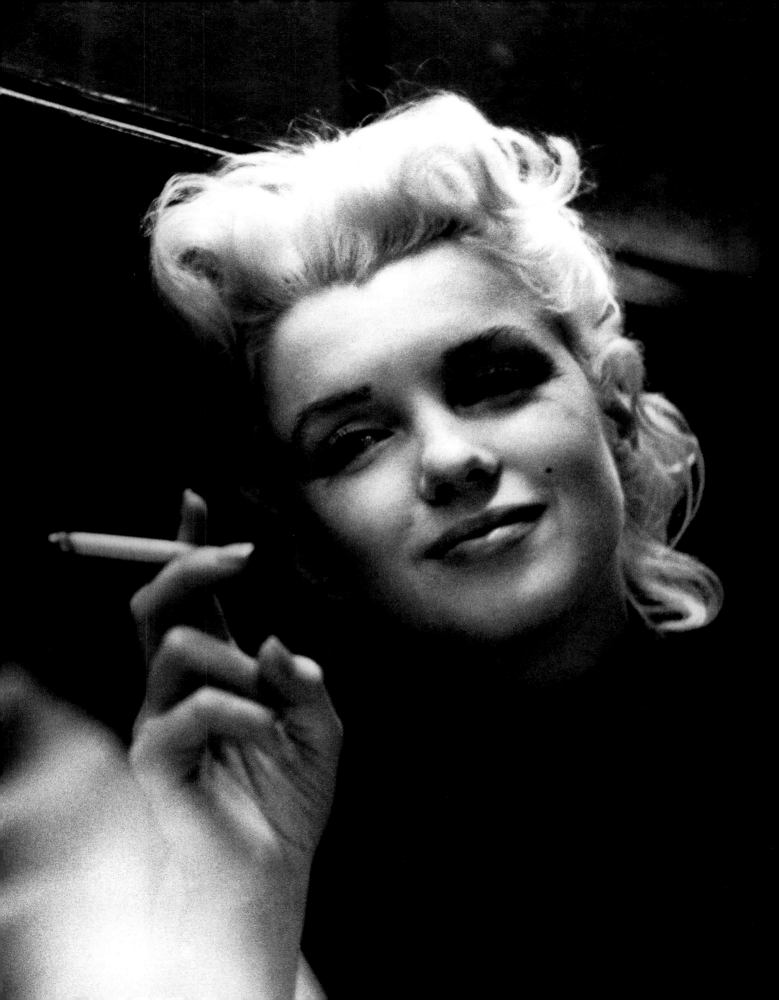

The Fall

parted ways, and he was no longer vice president of her production company. Monroe also stopped seeing her (and Greene's) psychoanalyst, switching to Dr. Marianne Kris, a close family friend of Sigmund Freud, whom she would visit five days a week. According to the biographies, there is little evidence that any of her decisions in this period led to greater emotional stability.

On the home front, Monroe hoped domesticity, time away from the movies and, most crucially, a baby might improve things. She and

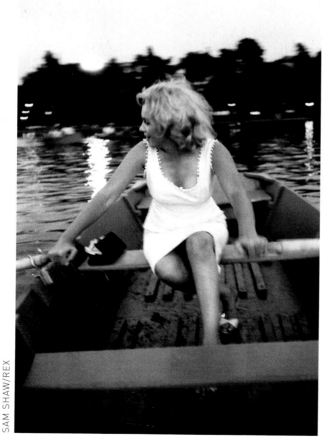

SAM SHAW/REX

In the fall of 1956, Monroe is in her, ahem, rowing outfit during a recreational sojourn on the lake in New York City's Central Park.

Miller spent the summer on Long Island, New York, where they tried to start a family. Monroe did conceive, but it turned out to be an ectopic pregnancy, in which the fertilized egg grows outside the uterus. Such a condition is most serious and can lead to the death of the mother. The pregnancy was terminated soon after, in August 1957, and Monroe, who desperately wanted a child, was shattered. She was gaining weight, drinking too much and, according to some sources, taking copious amounts of sleeping pills. The pills would, reportedly, lead to a string of overdoses in the years to come. Biographer Barbara Leaming says that not long after the pregnancy, Miller found his wife collapsed and breathing irregularly—a "sound [that] would become terrifyingly familiar" during the rest of their marriage.

Was there any refuge for Marilyn Monroe? No one could say, but in July 1958, with her husband's encouragement, she returned to Hollywood, after agreeing to play the part of Sugar Kane Kowalczyk in director Billy Wilder's *Some Like It Hot*. Her behavior on that production made what had transpired during *The Prince and the Showgirl* shoot look like a pleasant stroll through Kensington Gardens. She was routinely late, unsure of her lines and insistent on numerous retakes of the simplest scenes. The merest slipup could cause tears, which meant her makeup needed to be retouched. From a thermos, according to Leaming, she sipped vermouth throughout the day.

"We were in mid-flight," Wilder is quoted as saying in the Anthony Summers biography *Goddess*, "and there was a nut on the plane." Wilder

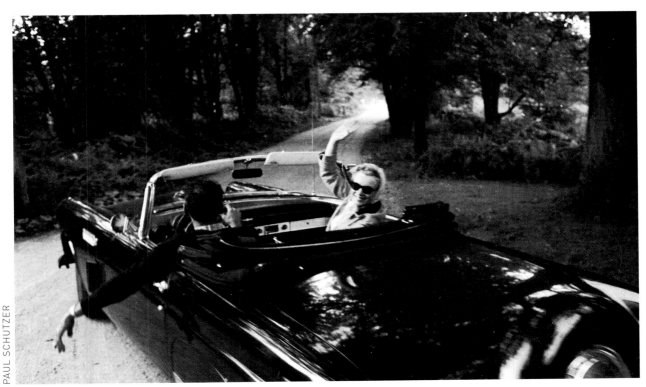

Also in 1956, newlyweds Arthur Miller and Monroe, already on the verge of waving goodbye to romantic bliss and proceeding upon a troubled four-and-a-half-year union, take a spin.

said elsewhere that instead of the Actors Studio, "she should have gone to a train-engineer's school . . . to learn something about arriving on schedule." He elaborated for biographer Donald Spoto: "To tell the truth, she was impossible—not just difficult . . . There were days I could have strangled her, but there were wonderful days, too, when we all knew she was brilliant . . . Yes, the final product was worth it, but at the time we were never convinced there would *be* a final product."

That product, which is regarded as a comedy classic today, was a smash hit, garnering six Oscar nominations. Monroe won a Golden Globe for her performance.

If we did not now know what was going on behind the scenes, this could be regarded as a high point of her life.

Monroe became pregnant yet again in the autumn of 1958. Yet again she miscarried. Yet again she took some time off, then returned to the business of making movies.

In 1959 and '60 she worked on *Let's Make Love*, a fraught production floating on a leaky script that had been doctored, unsuccessfully, by Arthur Miller. On the set, Monroe's conduct was what could now be characterized as "characteristic." Off the set, she had an affair with her costar, the French actor Yves Montand. While this can technically be seen as cheating on Miller, consider that even earlier, after meeting the playwright during the filming of *Some Like It Hot*, director Billy Wilder felt that "at last I met someone who resented her more than I did." There was no longer any love lost between the husband and wife—no love lost and no love left.

Miller had been working for a few years on a screenplay that at first he had intended as a kind of homage—a love letter—to Monroe. She was never enthusiastic about the depressed divorcée role Miller had written for her; she found it hit wholly too close to home. But the playwright was dogged in his determination to get the film

The Fall

made. The movie was *The Misfits,* and it would be the last that Monroe would ever complete.

She was hardly alone in causing problems on this set. The heat in the Nevada desert, where the film was shot in the summer and fall of 1960, was oppressive and had everyone on edge. Miller was constantly revising his screenplay, which didn't help matters, and constantly feuding with his wife. As for the director, John Huston: His penchant for drinking and all-night gambling left him so debilitated at times that he would fall asleep in the director's chair.

But if blame for the generally miserable atmosphere can be spread around, certainly Monroe merits her share. Her consumption of addictive barbiturates, which she sometimes pricked with a pin to hasten their effect, was on the rise, and she may have been taking other drugs as well. The medications can and apparently did cause depression, confusion and slurred speech. She was mighty difficult to awaken for work—some mornings, she was taken bodily to the shower and then her makeup artist would apply cosmetics while she lay in bed. The phrase *absolute mess* pretty well describes her condition. Her costar Clark Gable tried to support her, but it was an impossible task. At one point, Huston shut down the set for a week while Monroe was sent to a hospital to dry out and regain strength. (A note in passing: At least one of Monroe's biographers, Donald Spoto, asserts that Huston orchestrated the hospitalization so that he could take several days off to deal with his gambling debts.) Monroe returned to the set and, against all odds, finished the film. Gable reportedly said after the sets had been struck, "Christ, I'm glad this picture's finished. She damn near gave me a heart attack."

In early November, shortly after leaving Nevada, Monroe and Miller announced they were divorcing. Barely a week later, Gable died of a coronary at 59; there was speculation that the stresses of making *The Misfits* were a contributing factor. Monroe's depression was only made worse now by an overwhelming sense of guilt.

If Monroe even registered the critical praise accorded her and Gable's performances when *The Misfits* was released in January 1961, there was nothing that could improve her mental state. Her

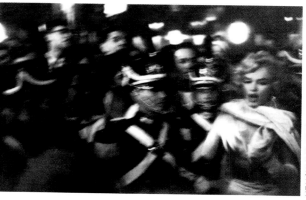
SAM SHAW/REX

At Radio City Music Hall in New York City, for the June 13, 1957, premiere of The Prince and the Showgirl, *Monroe is the eye of the hurricane.*

psychoanalyst Dr. Kris, by some accounts, worried that she was becoming suicidal and urged hospitalization. One Sunday in early February, Monroe checked herself into the Payne Whitney Psychiatric Clinic in New York City. Once inside, she panicked. Was the madness that had consumed her mother being visited upon her? She slammed a chair into some glass, breaking off a

By 1961, Joe DiMaggio, seen here with Monroe on a beach in Belleair, Florida, has reentered the picture. As it would eventuate: too late.

piece. When personnel returned to her room, she threatened to cut herself with it if they didn't let her go. "If you are going to treat me like a nut, I'll act like a nut," she told them. She was taken by force to another room where, she later wrote, the walls bore "the violence and markings" of previous patients. She heard the screams of other women. "I'm locked up with these poor nutty people," she wrote to Lee and Paula Strasberg in a plea for help. "I'm sure to end up a nut if I stay in this nightmare."

Three or four days after checking in (accounts differ), she reached Joe DiMaggio by phone in Florida. He rushed to New York and threatened Dr. Kris that he would tear apart the hospital "brick by brick" if Monroe was not released the next day. She was, and DiMaggio would stay in the picture from here on out. (Some biographers maintain that there was talk of a remarriage late in Monroe's life and even plans for one.)

Monroe spent three weeks recuperating at Columbia University Medical Center, then moved back to Los Angeles, where she would make daily visits to Dr. Ralph Greenson, a psychiatrist whom she had originally seen in 1960.

This stage of Monroe's life, as chronicled in dozens of biographies, each with its own point of view, becomes as hazy as it must have seemed to her while she lived it. What really happened between the last weeks of 1961 and August 4, 1962, depends entirely on which version a reader chooses to believe. Much of the murk involves the Kennedys and the extent of Monroe's relationship with them. According to some retellings, in October 1961, Monroe met Attorney General Robert F. Kennedy and the following month his brother President John F. Kennedy at separate parties hosted by their sister Pat and her husband, actor Peter Lawford. These would not be her last encounters with either brother, and it is a consensus view among her biographers that there was an affair between the actress and the President. Whether it went beyond a single night (one friend asserts that Monroe herself acknowledged a sexual liaison with JFK during a stay at Bing Crosby's house in March 1962) and whether there was also an affair with Bobby Kennedy is still debated—as is the theory that the Kennedys had something to do with her death, which we will get to shortly.

Monroe had signed to star in another film for Fox, *Something's Got to Give,* but in April 1962, when time came to shoot her first scene, she was too ill to report for work. She stayed out for nearly three weeks, put in a few days of work, then said she was jetting to New York to take part in a Democratic fund-raiser celebrating President Kennedy's 45th birthday. The studio, despite having earlier approved the trip, countered that if she left, she would be in breach of contract. She ignored her bosses and on May 19

The Fall

was introduced by Peter Lawford to 15,000 party-goers at Madison Square Garden. Shimmering like a disco ball in a dress as snug as plastic wrap, she proceeded to croon her best wishes to Kennedy in a voice somewhere between sultry and downright dirty. The President later told the crowd, "I can now retire from politics after having had 'Happy Birthday' sung to me in such a sweet, wholesome way."

Two weeks later, back in California, Monroe celebrated her own 36th birthday on the film set with a sparkler-studded cake; it would be her last day at work. When she didn't show up the following week, she was fired. The studio subsequently filed a $750,000 breach-of-contract lawsuit. Dean Martin, Monroe's costar on *Something's Got to Give,* said he would walk if Monroe wasn't brought back. Fox capitulated, and by the beginning of August, the studio signed Monroe to a second contract.

While she was negotiating this new deal, in July, Monroe met with LIFE's Richard Meryman for a series of interviews that would prove to be her last. At one point, she compared fame to caviar—"not really for a daily diet, that's not what fulfills you"—and said that celebrity could be a dangerous business: "You're always running into people's unconscious." She talked about being "picked on" and pulled apart, treated like a commodity. She vented her anger at the studio.

"Fame will go by and, so long, I've had you, fame," she said. "If it goes by, I've always known it was fickle. So at least it's something I experienced, but that's not where I live."

She said further: "I don't think people will turn against me, at least not by themselves. I like peo-ple. The 'public' scares me, but people I trust."

She added, again referring to the idea of fame: "It might be kind of a relief to be finished."

Meryman, upon seeing Monroe so agitated, asked if many friends had called to offer support. She paused and, looking hurt, answered softly, "No."

At the end of their interview, she implored Meryman sadly, "Please don't make me look like a joke!"

Biographical reports of Monroe's last weeks differ wildly. In one, she is a woman on the mend and in good spirits; in another, she's wresting control of her life from Dr. Greenson, with whom she had become disillusioned; in the next, she is addled by drugs and despair, careering toward her doom. Which was it? We'll never know for certain.

Of August 4, 1962, only a few details are generally accepted: We know that Monroe spent part of the day meeting with a photographer to approve for publication nude poses he had taken on the set of *Something's Got to Give.* She met with Dr. Greenson sometime in the afternoon and into the evening. Before 8 p.m., she took a phone call from her former stepson, Joe DiMaggio Jr. Shortly after, some accounts say, she was on the phone again, this time with Peter Lawford, who that night was having a small gathering to which she was invited. During their call, Lawford told police much later (his story undergoing revisions through the years), Monroe refused to join him. He said she was speaking in a slurred voice that became less and less audible. He yelled into the phone, trying to startle her, to no avail.

"Say goodbye to Pat," she said, according to

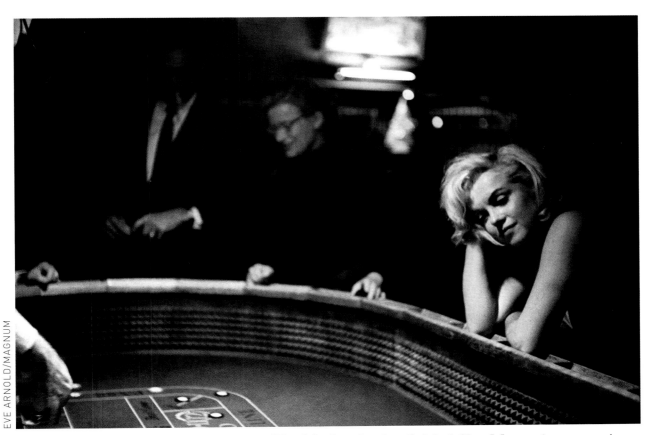

During a break in the tortured filming of The Misfits, *her last finished film, Monroe is at a gaming table of a casino in Reno, Nevada.*

Lawford. "Say goodbye to Jack. And say goodbye to yourself because you're a nice guy."

At some point during the night, Monroe's housekeeper, Eunice Murray, called psychiatrist Greenson to say she suspected something was wrong. Greenson rushed to the scene, broke into the room and called Monroe's internist, Hyman Engelberg. Engelberg arrived, inspected the body and called the police at 4:25 a.m.

A small cache of pill bottles, one empty, sat on a night table beside the bed where Monroe lay dead when police arrived. No suicide note was found (some accounts hold that there was a note of some kind and Lawford destroyed it). Tests conducted during the autopsy revealed the barbiturate pentobarbital and the sedative chloral hydrate in her blood and more pentobarbital in her liver. (Both drugs are used to treat insomnia.) The cause of death was ruled a drug overdose and probable suicide.

Circumstances, however, were muddied from the first by conflicting versions of the timeline, the possibility of tampering at the scene and questions about the completeness of the investigations by the police and the medical examiner.

When was Monroe's body actually discovered? Why was there a lag—perhaps of several hours—between that discovery and when the police were called? Why did the coroner receive results for only *some* of the lab tests? Was Bobby Kennedy in Los Angeles, as some have said, and did he visit Monroe? Might this have been a politically motivated murder done either by or on the behalf of the Kennedys—to protect reputations or state secrets? Alternately, was Monroe killed by an enemy of the Kennedys? Or was it, after all, just an accident?

"In all this discussion of the details of her dying," Norman Mailer wrote in his impressionistic 1973 book, *Marilyn,* "we have lost the pain of her death. Marilyn is gone."

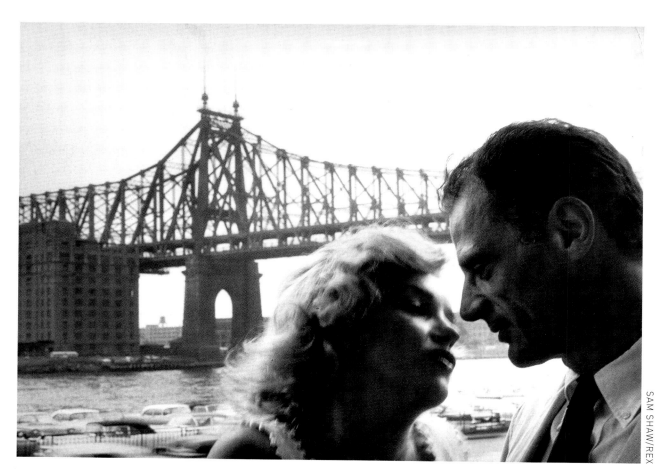

SAM SHAW/REX

Two scenes from 1956, with two men she has loved but would soon love less. Opposite, Milton Greene,
Monroe and Miller enjoy hot dogs and Cokes in New York, not far from where Monroe and Miller are
living in Roxbury, Connecticut—and, for that matter, not far from the Greene family home in Weston,
Connecticut, where she lived for parts of 1954 and '55. Greene is still, at the time of this photograph,
a top executive with Monroe's film production company. Miller, seen above with his wife in New York
City, also in 1956, is still bewitched. The status of both of these men will change quickly, as Greene will
split from the production company in 1957, and the bloom will fade from the Miller-Monroe rose with
similar alacrity. Just by the way: In the car-happy '50s, Monroe traveled in some truly fine vehicles. Joe
DiMaggio's ride was a black Cadillac, license plate JOE D. The black Thunderbird convertible pictured
opposite and also on page 105 may have been bought for her by Greene. These snazzy wheels would then
be succeeded as her chariot by Miller's Jaguar.

PAUL SCHUTZER

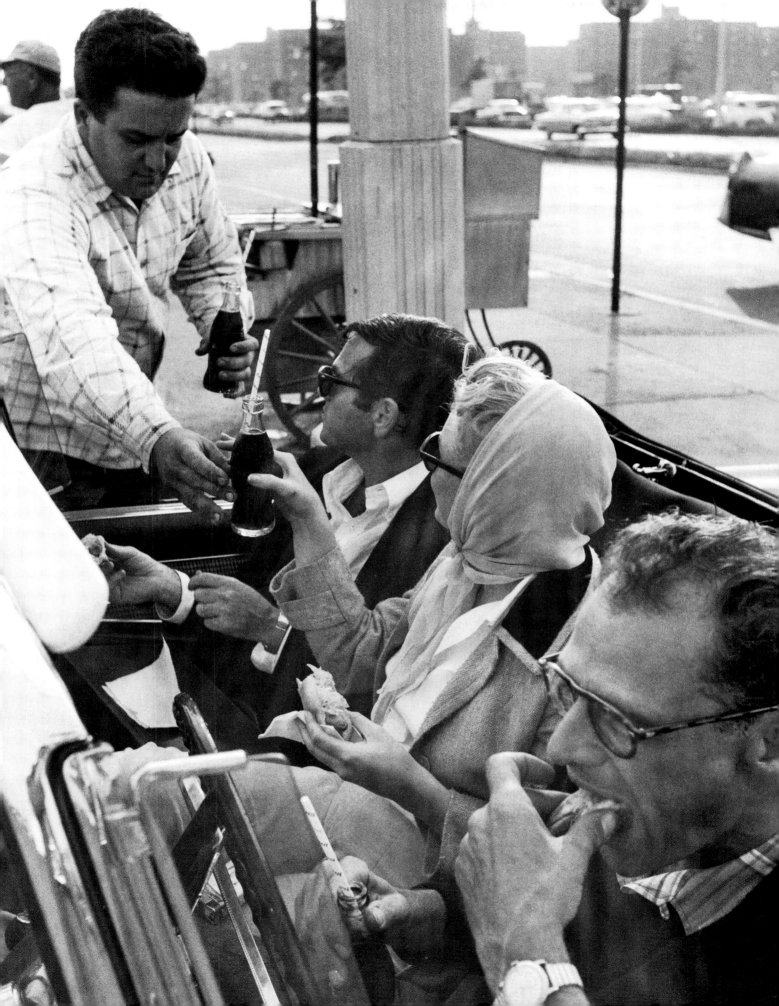

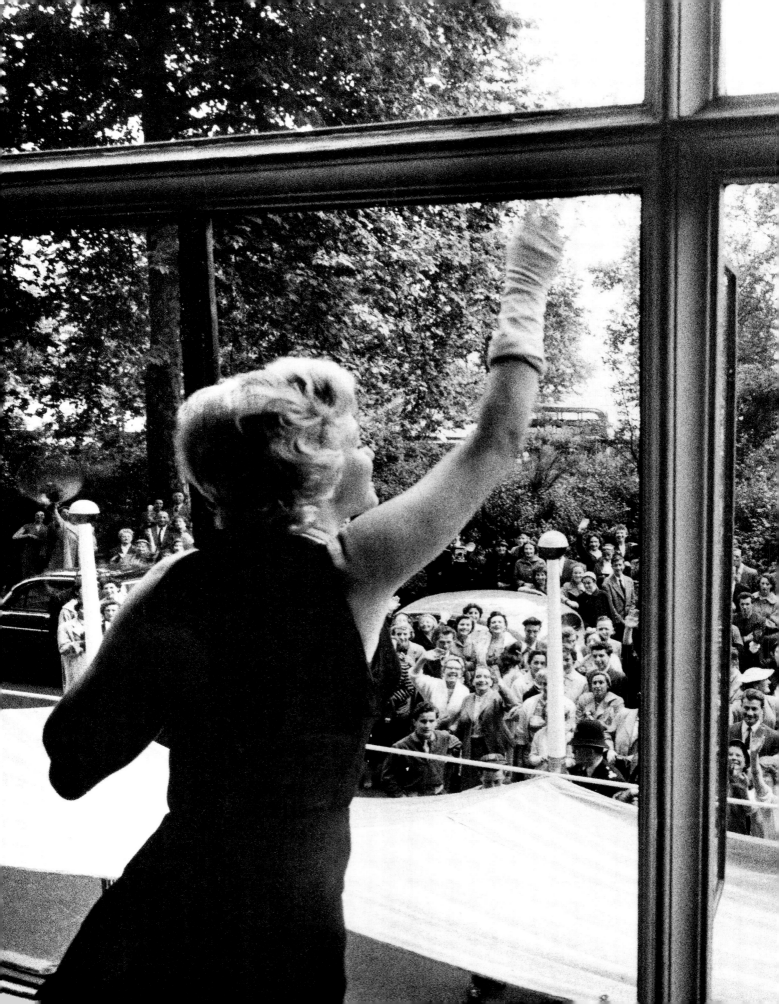

Monroe was the belle of the ball in London during the 1956 filming of The Prince and the Showgirl. *Opposite, she waves to her adoring fans through the windows of Parkside House, her luxury lodgings during the shoot. Above, local children, the great majority of them lads whose heretofore complacent youth has been sent reeling by the arrival of this sex bomb, stake out the gate. Having been tipped by Monroe's handlers, the boys have turned over a NO PARKING sign and written in chalk on the back: MARILYN NOT OUT TILL 4 P.M. That may deter other gawkers, but these fans will remain loyal and true. The photos here are all about gaiety and frivolity, but the production of the film is fraught. Monroe is as chronically late for her director, Olivier, as she no doubt was for these other male admirers; it is all but certain that they waited till later than four for a glimpse of the object of their ardor. Similar to the appearance-versus-reality nature of the London photographs, the picture on the pages immediately following, taken on the beach at Amagansett, Long Island, in 1957, fairly sings of happiness. But the exodus to Amagansett is embarked upon by Monroe and Miller to help mend their fraying marriage and produce a child. As we know, neither effort would succeed.*

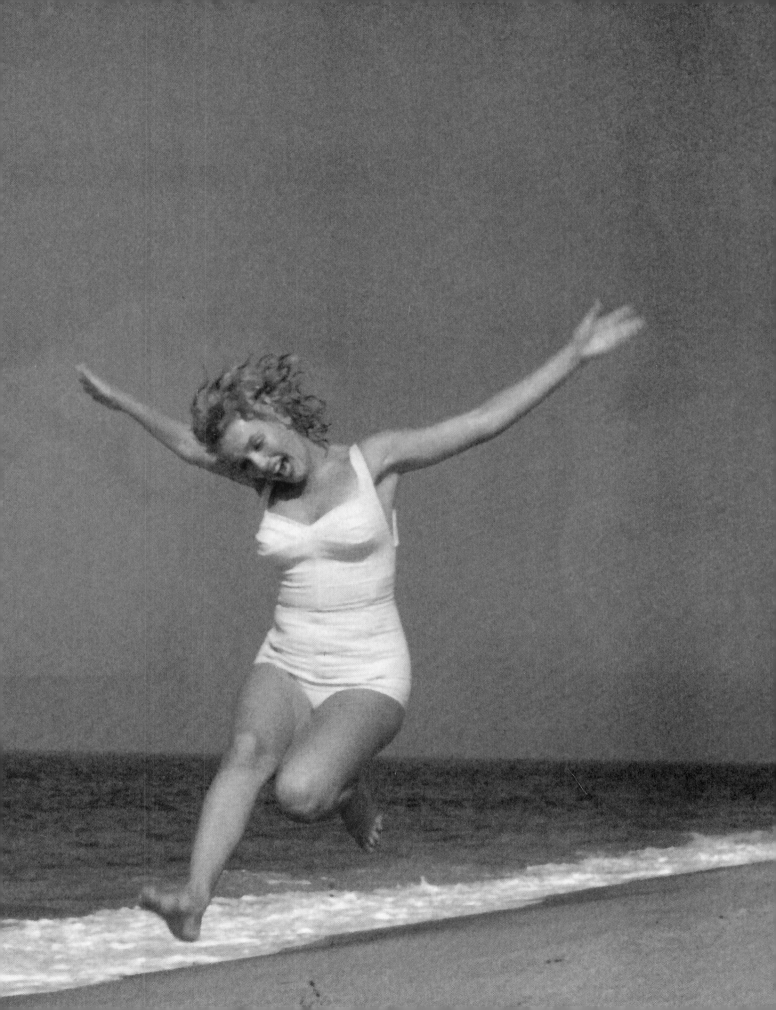

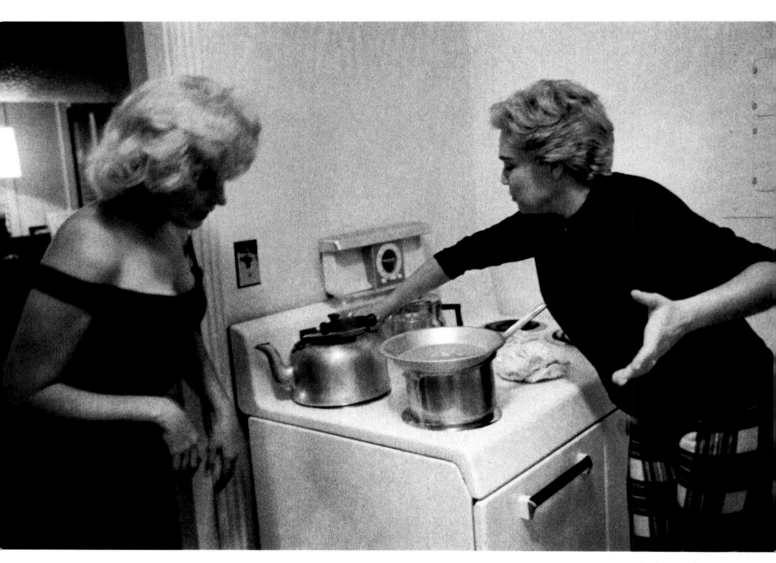

This is one bizarre (and rarely seen) pair of pictures. Above are Monroe, in her (ahem, yet again) cooking apron, and the French film star Simone Signoret, sporting garb more appropriate for the kitchen and certainly more appropriate for a 1950s housewife. They are preparing dinner for a party that will include their husbands, Yves Montand and Arthur Miller (opposite, breaking bread). This is during the 1960 filming of the Monroe–Montand vehicle Let's Make Love, *which is a phrase that proved to be a directive that Montand and Monroe took all too seriously offscreen as well as on. So what we have here is a group of very intelligent people socializing amid tension that must have been unbearable.*

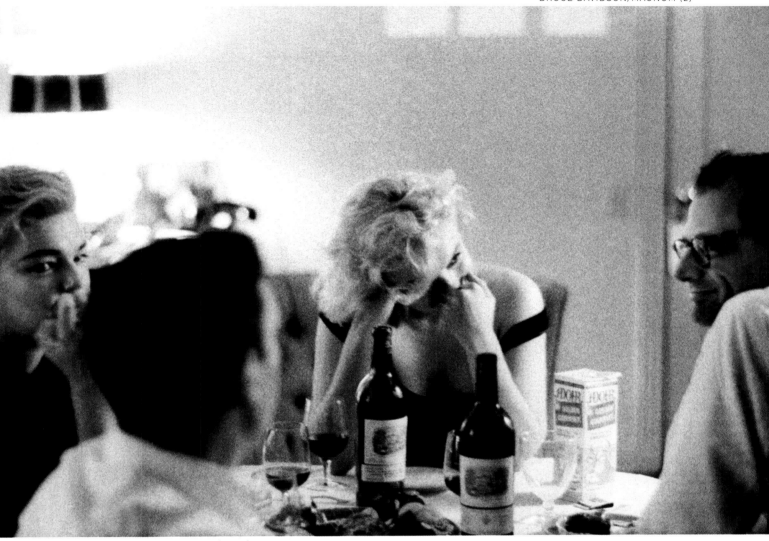

According to some accounts, Monroe hoped Montand would leave Signoret and stay with her. But he wouldn't, and therefore Monroe's marriage to Miller slouched forward for another year before dissolving. (Miller's first major play following Monroe's death, After the Fall, *would recount their always troubled union, and his last produced play, in 2004,* Finishing the Picture, *would revisit the chaotic production of* The Misfits.*) Later in 1960, Monroe would be offered support, and perhaps something like love, by her misfit costar Clark Gable (following pages). But the end was near—the end of all, not just the marriage to Miller or her stardom.*

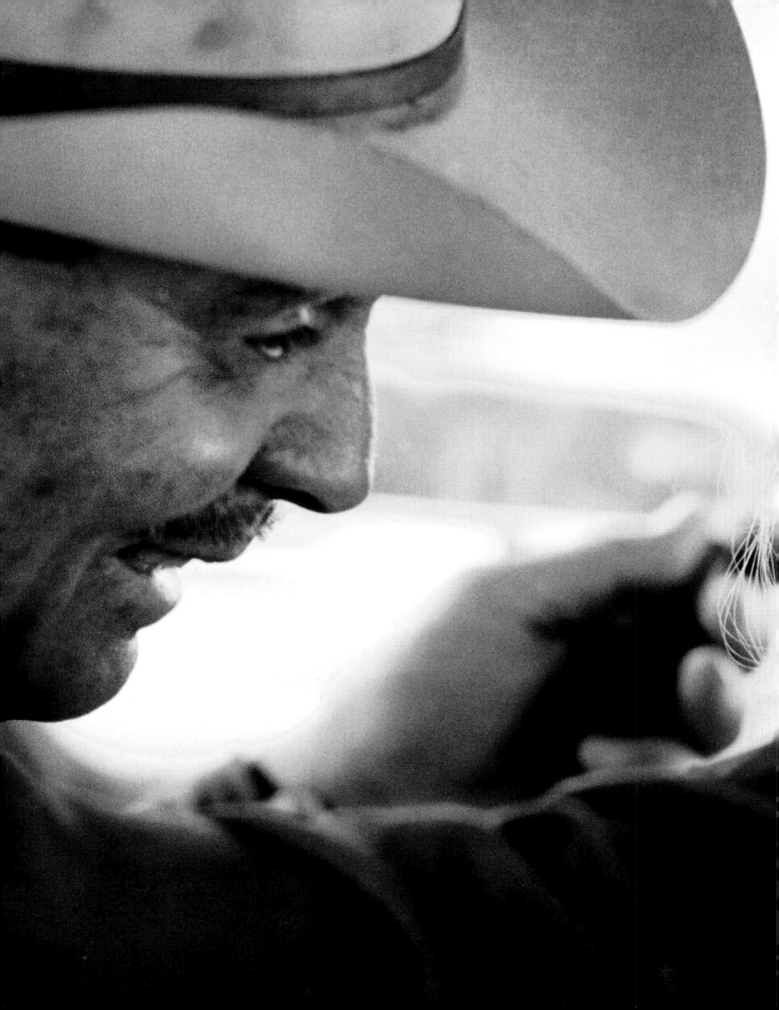

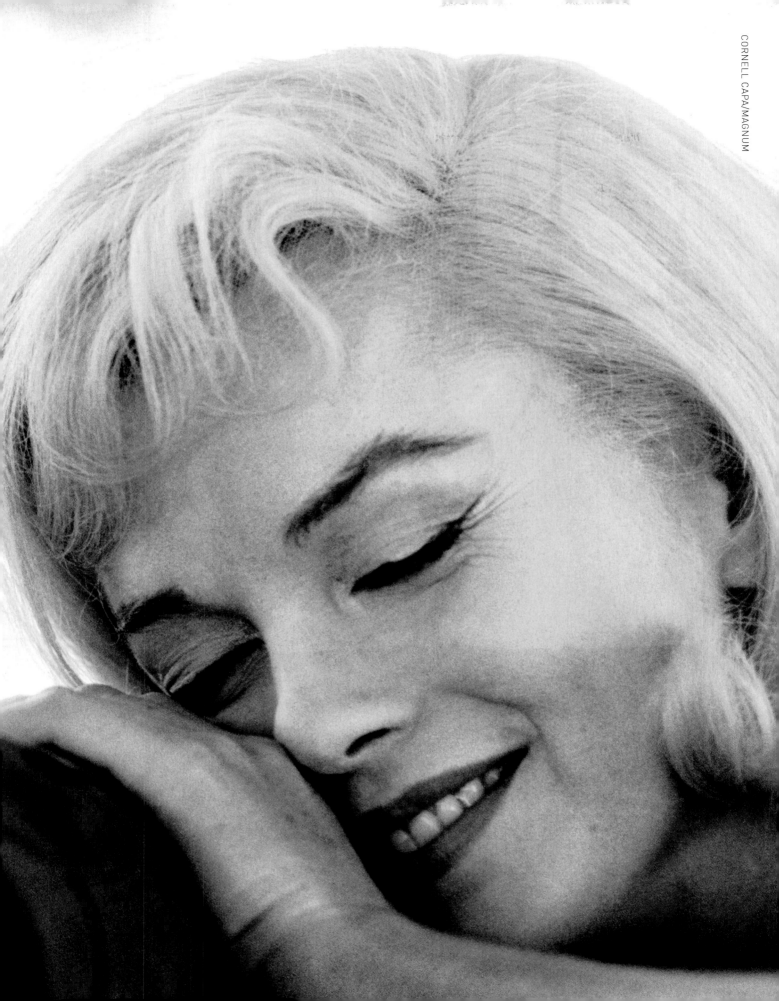

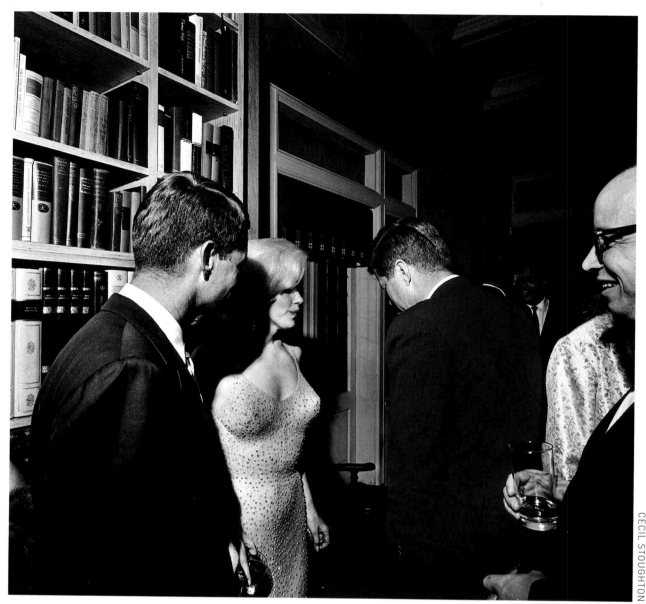

In a life filled with notoriety, the evening of May 19, 1962, was perhaps the most notorious of all, excluding the night of her death. At Madison Square Garden, she purred a lascivious rendition of "Happy Birthday" to President John F. Kennedy that all these years later on recordings remains shocking in its impropriety. She met over drinks later with Bobby and Jack Kennedy (above, flanking her), as well as their friend, the historian Arthur Schlesinger Jr. (above, at right), who wrote weeks later in his journal: "I must confess that the report yesterday of Marilyn Monroe's death quite shocked and saddened me (but did not surprise me). I will never forget meeting her at the . . . party following the JFK birthday rally . . . [T]he image of this exquisite, beguiling and desperate girl will always stay with me. I do not think I have seen anyone so beautiful; I was enchanted by her manner and her wit, at once so masked, so ingenuous and so penetrating. But one felt a terrible unreality about her—as if talking to someone underwater. Bobby and I engaged in a mock competition for her; she was most agreeable to him and pleasant to me, but one never felt her to be wholly engaged." A half century later, the short, sad association of Monroe and the Kennedys is part of grandiose American mythologies—both hers and theirs. But in its time, it was merely a mistake: reckless behavior leading to no good end. To what extent Monroe was truly invested in the brothers will likely never be known precisely, no matter how many revisionist biographies we are presented with. Whether the Kennedy family had anything at all to do with her death—beyond causing additional sadness—will also be forever debated.

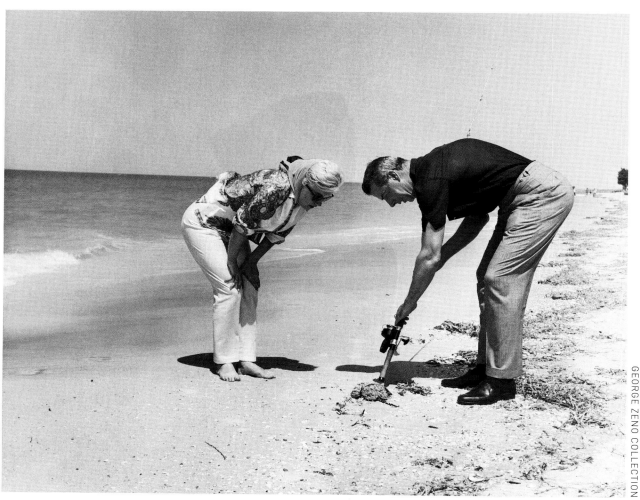

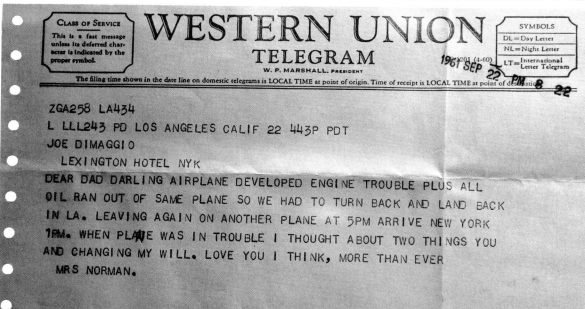

CLASS OF SERVICE
This is a fast message unless its deferred character is indicated by the proper symbol.

WESTERN UNION
TELEGRAM
W. P. MARSHALL, PRESIDENT

1961 SEP 22

SYMBOLS
DL=Day Letter
NL=Night Letter
LT=International Letter Telegram

The filing time shown in the date line on domestic telegrams is LOCAL TIME at point of origin. Time of receipt is LOCAL TIME at point of destination.

```
ZGA258 LA434
L LLL243 PD LOS ANGELES CALIF 22 443P PDT
JOE DIMAGGIO
   LEXINGTON HOTEL NYK
DEAR DAD DARLING AIRPLANE DEVELOPED ENGINE TROUBLE PLUS ALL
OIL RAN OUT OF SAME PLANE SO WE HAD TO TURN BACK AND LAND BACK
IN LA. LEAVING AGAIN ON ANOTHER PLANE AT 5PM ARRIVE NEW YORK
1PM. WHEN PLANE WAS IN TROUBLE I THOUGHT ABOUT TWO THINGS YOU
AND CHANGING MY WILL. LOVE YOU I THINK, MORE THAN EVER
   MRS NORMAN.
```

Is it pure romance to say he did his best to save her? Whether yes or no, Joe DiMaggio was there at the end, as he had been throughout. Top: Inspecting a horseshoe crab on the beach in Belleair, Florida, in March 1961. Opposite: On opening day at Yankee Stadium, a month later. The telegram from Monroe posing as "Mrs. Norman," rarely seen, speaks for itself.

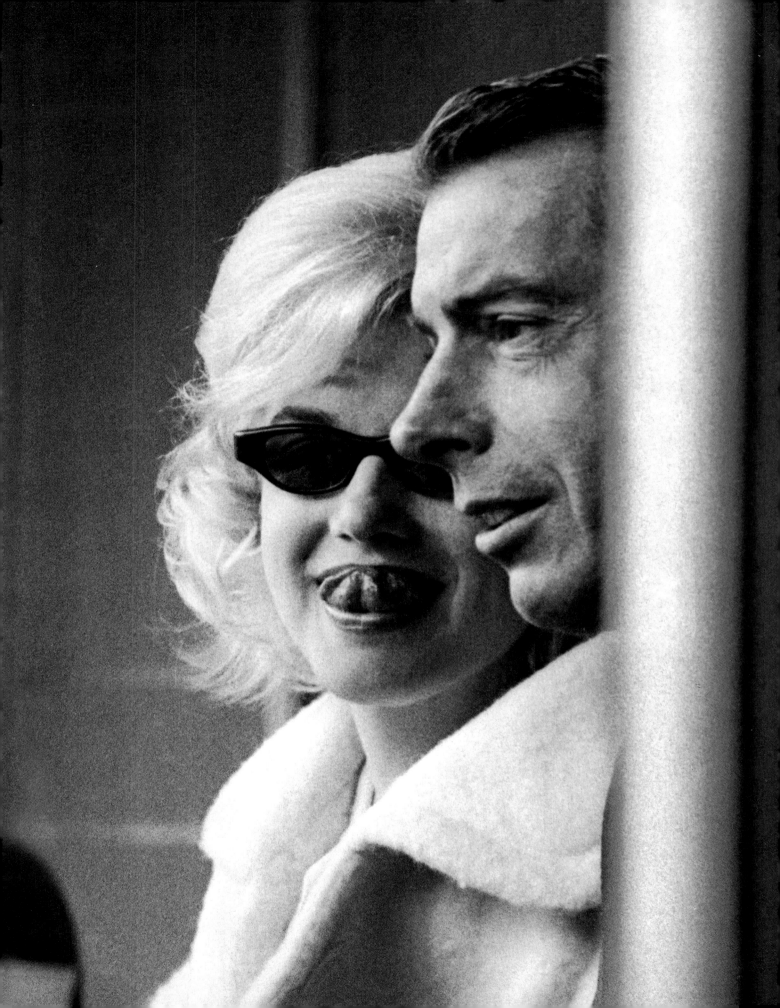

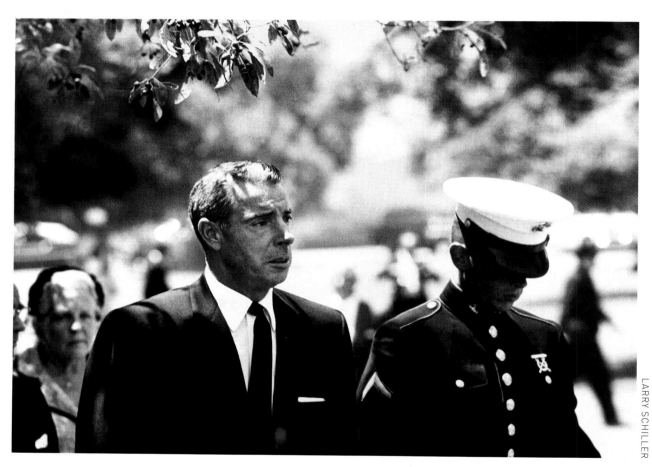

DiMaggio was at the funeral; James Dougherty, Arthur Miller and, for that matter, Robert Slatzer were not, though all were still very much alive. Monroe's half sister, Berniece, was there as well, having made the journey at dear expense. So many who professed to love her weren't there, and so few were. The great expansive public was there, in its prayers and sympathies and lamentations if not its physical presence, which of course was impossible. In an intensely private ceremony on August 8, 1962, she was interred in a crypt in the vast Westwood Village Memorial Park in Los Angeles. Flowers would adorn that crypt for a score or more years, because DiMaggio had so promised. Joe kept his promises.

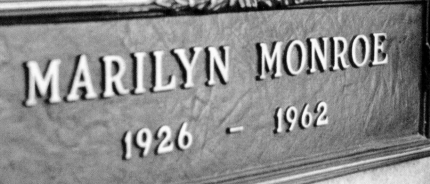

Goodbye, Norma Jeane

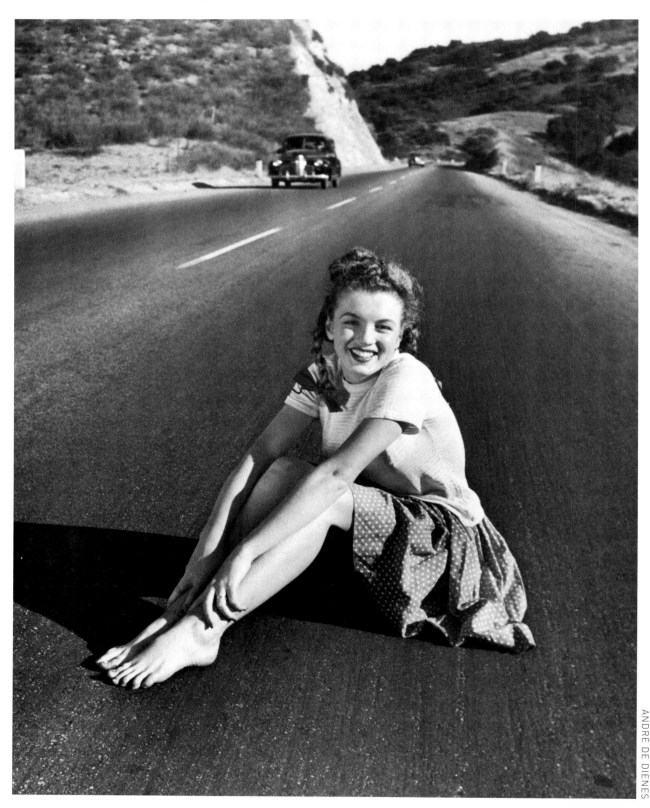

Marilyn Monroe, née Norma Jeane Mortensen, 1926–1962

Your World in Pictures

LIFE.com is the largest, most amazing collection of professional photography on the Web, featuring literally millions of images from the unparalleled LIFE archives. With iconic and never-before-seen photographs of beloved stars like Marilyn, Audrey Hepburn, Frank Sinatra, and others, LIFE.com tells the story of our lives — our heroes, our stars, our celebrations and our heartbreak, one astonishing picture at a time

Find Photos... **SEARCH**

⌂ MAKE THIS MY HOMEPAGE

 NEWS

 CELEBRITY

 TRAVEL

 ANIMALS

 SPORTS

Celebrities Today

1 of 18

MARILYN MONROE EXCLUSIVE: Never-Before-Published Photos

An astonishing gem from our archives: LIFE reveals a newly discovered set of photos of a pre-fame Marilyn Monroe, at age 24, spending a day at L.A.'s Griffith Park.

See More Marilyn Monroe: Never-Before-Published Photos

What's Popular in Celebrity

See All Celebrity Galleries

Sort by: **Most Viewed** **Most Recent**

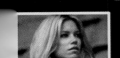
9 Hottest Sports Wives (and Exes)

Marilyn Monroe: Life and Times

MTV Movie Awards 2009

EXCLUSIVE
MARILYN: Never-Published Photos

Editor's Picks

Marilyn Monroe: Life and Times

LIFE EXCLUSIVE! The Day MLK Died

Sexy or Sleazy?

Sexy
or
Sleazy

If you liked this book, you're sure to love...